D1361057

Deep in the Mountains

DEEP IN THE MOUNTAINS

An Encounter with Zhu Qizhan

TERRENCE CHENG

WATSON-GUPTILL PUBLICATIONS
NEW YORK

COPYRIGHT © 2007 BY TERRENCE CHENG

First published in 2007 by Watson-Guptill Publications,
Nielsen Business Media, a division of The Nielsen Company
770 Broadway, New York, NY 10003

All rights reserved.

Library of Congress CIP data is available from the Library of Congress.

ISBN-13: 978-0-8230-0423-2
ISBN-10: 0-8230-0423-6

Printed in the U.S.A.
First printing, 2007

1 2 3 4 5 6 7 8 9 / 14 13 12 11 10 09 08 07

To the memory of my grandmother, Pao Imin,
whose paintings still adorn our homes and our lives.

Preface

In 1992—the year in which this novel is set—the city of Shanghai was in a remarkable state of development. After the Tiananmen Square Massacre in 1989, the great nation of China seemed determined to move beyond past tragedies by forging a bright and strong new future. China's economy was booming, and the standard of living for many Chinese, particularly in urban areas, was markedly improving. Long gone were the chaotic and xenophobic days of Mao Zedong. To borrow ideas and trade with the West was no longer considered a crime, but an integral part of the path to richness and prosperity.

During this incredible social, cultural, and economic expansion, amidst the skyscrapers, airports, museums, and shopping malls being built at a record pace (particularly in Shanghai, China's largest city) lived Zhu Qizhan, considered at the time China's greatest living artist.

In 1992, Zhu was already one hundred years old. He lived a quiet and simple life, dedicated to his work, and even at the age of one hundred, was still pushing himself, still experimenting with color and form. This is evident from Zhu's *shan-shui* (mountain-river) paintings done in that year alone. *A Lovely Day*, *Mountain Mist*, and *Good Mountain, Fine Day*, all

demonstrate Zhu's remarkable skill at evoking spirit and emotion with his energetic style and trademark use of dramatic and unconventional color. Other notable landscape paintings done in that year are *The Song of the Silver Woods, At the Height of Inspiration,* and *Dwelling in the Mountain* (the painting featured on the cover of this book). Though landscapes and mountains are part of the classical Chinese painting tradition, one wonders if the mountain's symbol of long life, mystery, and tranquillity, as well as its deeper meaning of being full in spirit and close to one's personal gods, held even greater meaning for Zhu in the final years of his life.

The title of this book comes from a painting of Zhu's done in 1974. *Deep in the Mountains* is a classic Zhu landscape depicting a winding white river among azurite trees, twisting between hulking walls of stone, coming high from the mysterious mist-laden peaks of the mountain. In the river are five rafts being sailed by single boatmen, who appear almost lost, small and powerless, yet a perfect part of the natural scene, unconscious of the grand majestic beauty around them. Master Zhu might have seemed like them, walking the streets of new Shanghai, a man who had lived through the last hundred years of China's tumultuous history. A perfect balancing presence he must have been in the burgeoning roar surrounding him.

Even more amazing than his work may be all that Zhu Qizhan endured during his one hundred and five years of life, the sacrifices he made and the integrity he always maintained as an artist. Only a man of great character and special talent could have persevered through the challenges that faced Zhu Qizhan. In his story, and in Tony's, I hope readers will find inspiration.

CHAPTER 1

*M*ay 1992

"Tony," his mother called from the front counter, the phone receiver still wedged between her shoulder and her ear. "Pick up the other line and stop daydreaming!" she ordered in Chinese.

"I'm not daydreaming," Tony said in English. "I'm working." But his mother had already gone back to scribbling on her notepad, and Tony knew she couldn't have heard him over the splashing and sizzling sounds coming from the kitchen, or the trill of the other phone line still ringing.

He was in back helping his father, refilling bowls of garlic and spices and cutting vegetables on the big steel prep table. The cook had called in sick that day, so his father had to take over. Tony watched as his father worked over the iron woks, his lean, wiry forearms tensing and flexing as he flipped and stirred and swirled the big black pans filled with vegetables and noodles and slices of chicken. "Do what your mother says," his father ordered without looking at him. Tony thought his father looked much older like this, wearing a long-sleeve white shirt and stained apron, a triangle-shaped paper cook's hat plastered by heat and oil to the top of his head, his face red and lined and sweating over the steaming range.

He left his father in the kitchen, went over to the phone next to his mother's, and punched the flashing button with one finger.

"Jade Dragon, can I help you?"

The order was a typical one: hot and sour soup, fried pork dumplings, General Tso's chicken, can of Coke. He took down the order and turned to bring it back to the kitchen. His mother grabbed him and handed him two additional sheets from her pad. Tony stuck the incoming orders on a hook next to his father.

"Sorry, Dad."

"What you sorry for?" his father said. "Always busy on weekend. Busy good. Go get more carrots."

Tony went into the cooler to retrieve the carrots, then went back to helping his father assemble the orders. He scooped white rice into small cartons, ladled soup into plastic containers, packed a quart-sized carton full of lo mein, bagged handfuls of fried chicken wings. He brought the orders up to the front counter, where his mother was still perched on a stool, her head perpetually cocked at an angle, the phone glued to her ear. She pointed at the four small tables in front littered with empty cups and plates and orange trays, and Tony moped out from behind the counter and cleared away the greasy half-eaten food. He could feel his stomach rumbling, looked at his watch: only one-thirty. Another six hours of this, at least. He wished he were home drawing, or on the roof of his building, or in an alley somewhere hidden behind a dumpster with a spray can in his hand. He wished he were anywhere but here, away from his parents who seemed like they were always on top of him, watching him.

Two older women came in to pick up their delivery, followed by two young men wearing clothes spattered in paint, all of them speaking Spanish. Through a half-oval opening in the clear Plexiglas divider (his father had told him it was bulletproof, but Tony knew better) Tony took their money and gave them their food. He was glad none of them sat down to eat—less mess for him to clean. A couple with two small chil-

dren came in and sat to wait for their order. He felt his stomach rumbling again.

"I'm going to get some pizza," he said to his mother, who was momentarily off the phone.

"Pizza? Why don't you just eat something here?" As always, his mother spoke Chinese and Tony spoke English. He could sense the couple waiting out front watching them, listening.

"I'm just going to get a slice, okay? I'll be right back."

"Pizza bad for you," his mother said in English.

He stepped out onto the sidewalk, wondering why his mother always had to give him a hard time any time he wanted to eat something besides Chinese food. Didn't she get it? He couldn't swallow another bite, not after fixing and cooking and smelling it all day. There were times after leaving the restaurant, even after taking a steaming hot shower, he swore he could still smell the pungent odor of cooking oil soaked into his hair and skin.

But it wasn't just what he ate that his mother gave him a hard time about—it was any time he wanted to go anywhere outside of school, the restaurant, or their apartment, even somewhere as close as the pizza place right down the avenue. It wasn't like he was going to get lost. He was fifteen years old and they had lived in the Bronx for over ten years, and he had been helping out at the restaurant for as long as he could remember—in the kitchen, taking and preparing orders, working the counter and register, refilling napkin holders and soy sauce and duck sauce packets on the tables, sweeping, mopping, wiping, even learning how to replace various parts on the soda fountain. Their apartment was on Vyse Avenue, only a few minutes walk from the restaurant on East Tremont, and all around the neighborhood Tony knew every street, every alley, every nook and crack and secret pass. He was sure he couldn't get himself lost or into trouble if he wanted to.

Outside, the streets were bustling. Mothers pushing strollers with small children clinging to their pant legs, a handful of older Hispanic men sitting

in front of the bodega playing dominoes on a board, a ring of bystanders watching; high school couples strolling lackadaisically hand in hand. Cars driving by, windows down with salsa music tingling or rap pumping the air; an old man in a faded gray suit and knotty salt-and-pepper hair with a Bible raised in one hand, his other hand covering his heart, his face turned toward the heavens as he sang and danced and prayed in the street. Tony passed a tenement with razor wire draped over the top of the gate like thick clusters of rusted leaves, a handful of girls inside playing hopscotch and jumping rope and singing loud happy songs.

Inside the pizza place, the man behind the counter smiled at him. "Gordito, you want the usual?" Tony nodded. He knew what "gordito" meant, didn't care, didn't feel like the man was being malicious or mean-spirited. He took it as a nickname like "buddy" or "pal," a friendly gesture because they saw each other all the time, either Tony buying lunch in his place or they were walking past each other on the street since their restaurants were so close by. Sometimes the man gave him a free soda, but not today. Across the counter the man slid two slices warm, not hot. Tony sat and wolfed down the first slice, then went back outside with the other slice on a paper plate.

He liked walking and eating pizza, something relaxing and enjoyable about hanging a slice from his lip and pulling the stringy cheese up into his mouth. He felt a breeze blowing, watched a torn-up newspaper litter the sidewalk, ruffling and scattering beneath parked cars and across the street. He stopped to watch the domino game as he finished his second slice. All the men ignored him. Then he saw the flavored-ice lady with her cart on the corner, scooping and dousing small heaps of red, orange, and blue crushed ice into paper cups, a handful of buzzing children and their mothers circling around her. Seeing her was a sure sign that summer was only a few weeks away, and Tony couldn't wait for summer, to be out of school, no more studying or homework or books. He would have to work more at the restaurant, but at least for that he would be paid. He was not

paid to go to school, to endure the harassment of fellow students or the grief of teachers.

And for what? he often wondered. Sometimes he imagined himself working in the restaurant full-time with his family, learning the business, growing it, eventually selling it. Or maybe he would set up a chain of Jade Dragon restaurants across the country and make him and his parents rich. They could move out of their old Bronx apartment and into a big house in New Jersey or Long Island or Westchester, a house with a huge green lawn and a deck for a barbecue, and his own room and a dog, and he could drive into the city to manage the restaurants, because by then his mother and father would be too old to haul themselves into work every day. What did algebra, the French Revolution, and the cotton gin have to do with the future of business, with money?

But he had heard his parents say it thousands of times (always in Chinese), whenever he came home with an A-minus instead of an A, or was acting lazy at work, or was eating too much: "We came here for you, not us. For you to be successful, for you to be happy." They had moved from Shanghai to Chinatown, New York, before Tony was born; and when he was five they left Chinatown to start Jade Dragon in the Bronx, where there would be less competition. But ten years later they still only had that one restaurant, still lived in that same apartment on Vyse Avenue (not a horrible apartment, but not a beautiful one either). He still heard his parents each month having that same conversation about money and bills and trying to do more than just make it by.

So he went to school—because it was what his parents wanted, because it was all he knew how to do.

He saw the old man with the Bible on the street corner, still singing, still dancing.

"You need God, boy. We all need God," the old man said, looking right at Tony.

"I know," Tony said. "I'm sorry. Thank you." Which was what his

mother and father had taught him to say if anyone at the restaurant ever got angry or complained. Look confused. Act like you don't know what they're saying. Say "sorry." Say "thank you." Give them a free soda or egg roll; you don't want any problems. Eventually they will calm down and go away.

They did not eat dinner at the restaurant. Instead they waited, especially on weekends, to go home and cook and eat dinner as a family. Tony remembered a handful of times, years ago, after a long day and with the restaurant closed, they had tried to eat at one of the tables in the front of the restaurant. But without fail there were always passers-by, no matter what the hour, who would see them and think the restaurant was open and would want to come in just to order an egg roll and a can of soda or a small box of fried rice. It was bad business to turn people away, his parents both agreed. Don't want to get a reputation as being rude. So they no longer stayed late to eat where people could see them.

At home, Tony's mother made a cucumber soup, fried pork chops, and a plate of chopped stir-fried vegetables. Steamed white rice, of course. No meal came without steamed white rice. After his pizza lunch, Tony thought his mother's cooking would be tolerable again. They ate without speaking. Tony reached across the table for a pork chop, and his mother tapped his hand with her chopsticks.

"Eat the vegetables," she said. "And the soup."

"You need to lose weight," his father said. "You know, girls don't like fat boys."

Tony's mother glared at his father, who kept eating, his mouth full and slightly open. Then she turned to Tony and said, "Have half a pork chop."

But Tony's stomach felt suddenly shriveled and dry, as if it had been filled by a bucket of wet hot sand. He took glances at his father as they continued to eat, and his father didn't look up even once. When his father finished eating, he left his empty bowl and plate and chopsticks on the

table and went across the room to the couch, where he turned on the television and put his feet up on the coffee table. His father was a thin man, all bones and sinew and angles. His mother was skinny as well. So how was it that he was their son? Tony sat staring at his father's empty plate, the pork chop bone gnawed clean.

"I'm tired," Tony said. "I'm going to bed."

"Good," his father said. "Tomorrow you have to help clean the cooler. I have a feeling that damned cook isn't going to come in again. So if I cook, you clean."

Tony said, "Good night," waved at his parents, now both sitting on the couch, and went to his room.

His room was small like a box, barely big enough to fit his bed, plus the desk and dresser in the corner. On his walls he had hung posters of rappers that he liked—Tupac and Ice-T and Public Enemy—to the frowning dismay of his parents. His closet was filled with clothes that had not fit him in years, clothes that he had outgrown (some in length but most in girth) that his mother refused to let him throw out. Did she think that he would wake up one morning having shed thirty or forty pounds? Maybe she did. Tony knew better. He was five feet two inches tall and weighed one hundred and seventy pounds, and nothing about his height or weight seemed imminently inclined to change. He dimmed the light in his room and looked out the window. From their apartment he could see and hear the subway screeching and rumbling by like a crippled iron snake, the flashing red taillights of cars speeding over the Cross Bronx Expressway. In the distance he imagined he could see and feel the glow and buzz of Yankee Stadium: baseball, another sign that summer was near.

On the back of his door was a full-length mirror. He took off his shirt and stood in front of it. Did he really look so bad? He sucked in his gut and still a tube of fat hung over his belt line. He pushed back his shoulders, but to no avail as it only seemed to jiggle and bounce the rolls around his stomach and chest even more. He stepped up close to the mirror and

rubbed the double chin under his face, tried to suck in his cheeks. He wished he were taller, of course, but he thought he could live with being short if only he weren't so fat. It would be a fair trade-off. He wondered if there was a god of weight-loss he could pay homage to during the Chinese New Year that might answer his prayers.

He flicked and poked at the flab on his arms, then got down on the floor, lying on his chest. He squeezed through two sets of ten push-ups, his back bending, knees almost touching the ground, trying not to grunt or breathe too loudly lest his parents hear and come in and intrude. After that he flipped over for sit-ups, slow, grueling, neck-pinching, back-breaking sit-ups. In gym class last year, when they did physical fitness tests, he had been able to do only fifteen. These days he was determined to do at least twenty every night (or any night he remembered or felt angry enough to do them).

As he went through his routine he heard the voices in his head, remembered that day at school two years ago when all other jokes and gestures and slurs were replaced by one word; no more "chink" or "jap" or "gook" or "slant-eye"—to the kids, they were all the same anyway, a slur was a slur, didn't make a difference if it was racially accurate. It was Victor Ramirez who had said it, Victor who had always been the tallest and most popular of the boys in his class, with his perfect tan skin (how did a kid in ninth grade not get zits?) and his bigger-and-stronger-than-normal athletic build (he had to have been left back at least once, Tony believed). Tony was walking the halls between classes, saw Victor coming through the crowd, and he knew Victor had spotted him and had saved up a good one-liner to hit him with, could tell just from the cocky smile on his face.

"Hey, Cheung," Victor said, loud so everyone could hear him. "You so fat, we ain't even gonna call you 'chink' no more. We just gonna call you 'chunk'—that alright?"

And the hallway exploded with laughter, girls and boys, maybe even teachers; some pointed, some just stared, and Tony tried to keep walking as

if nothing had happened. But something had, he knew it, could feel it, as if the word *chunk* were now tattooed across his back and forehead; could see Victor in a kind of tunnel vision, all his cronies surrounding him, laughing, slapping high fives.

When Tony finished his sit-ups, he was sweating. He sat on the floor listening, heard only voices coming from the television echoing through the thin walls of the apartment. He put on his shirt and poked his head out, saw his mother leaning her head on his father's chest, her eyes closed, his father's head tilted back, snoring. The empty plates and leftover food were still on the table. He stepped out into the living room and poked his mother, then his father. They both looked up at him, red-eyed. His mother smiled.

"Go to bed," he said. "I'll clean up the dishes."

His parents stood, and his mother kissed him on the forehead. She was a small woman (Tony was only an inch or two taller than her), but she had a voice like a megaphone and a stare and presence that could freeze a room. She hugged him and said, "You're a good boy." Tony watched his parents go to their room and close the door, and he scraped the empty plates and began washing the dishes. When he finished he grabbed a pork chop out of the refrigerator and snuck back to his room, where he ate it next to the window. His mother was indeed an excellent cook, he thought. Nothing like the fast food they whipped up at the restaurant. He wiped his hands on his pants, then dug underneath his bed for his book bag to retrieve his sketchbook and pencils. As he did every night, he would stay up for the next few hours after his parents had gone to sleep, and either lying in bed with the sketchbook propped in his lap, or sitting at his desk if he were in a more serious mood, he would draw and doodle, line and trace the wild visions and shapes and colors that screamed through his brain and fingers and eyes to live somewhere outside his head.

CHAPTER 2

Every day he walked to school by himself, even in the rain or snow, the school not far enough away for him to take a subway or bus. But he did not mind it so much these days, actually appreciated the quiet, the ability to think and not be bothered.

Along his route he passed a bodega, and for as long as he could remember there had always been graffiti on the side of the wall—stray tags and scrawls, messages and swirls, blots and bursts of paint. Sloppy mostly, done by kids from the neighborhood, bored or taking dares, just a few seconds to make their mark and run. The store was on a corner of the avenue, which meant that people—and more important, police—could be watching from at least two sides. Too dangerous, he thought. He would never have taken the chance himself.

Which was why he was even more surprised when he saw that the wall had been covered by a mural: a clean field of silver with white-and-blue bubbly clouds spread across and from top to bottom, beams of golden light shooting through carrying tiny winged angels; in the middle an over-sized portrait of a baby boy and a young woman, both of them smiling, the boy with fat cheeks and big, dark almond eyes and curls of wispy black

hair; the mother with long, wavy flowing hair and a beautiful glowing face, holding the boy close and staring at him with those same glimmering eyes. The words across the bottom in a sweeping cursive script, *"Pedro y Isabel, Por Siempre Mis Amores, 1992."*

Tony had heard about them on the news the other day—a mother and son killed by a hit-and-run driver as they were crossing the avenue. Tony wondered who had painted the mural. Could it have been the father; or had it been friends, or neighbors? Maybe it was a lone artist, a stranger. Tony liked the idea of this: an anonymous good Samaritan armed with only his imagination, his sketchbook, and his paint, spurred to action in the name of the man whose family was no longer with him. Maybe the storeowner had been approached with the idea of this tribute, and maybe the store-owner had said, "Yes, I give you my wall," because he had known the man and his family (as Tony had not; when he heard the story and saw the faces he did not recall them ever coming in the restaurant). Or maybe the store-owner had said nothing and had simply let the painter do his job in silent approval; and maybe the police had done the same, and now the mural stood like a shining monument to the memory and beauty of this mother and baby boy.

Whoever had done it, and for whatever reason, Tony thought it was magnificent.

All his life he had seen graffiti like a special lens carved into his eye, the wild, scrawled blazing visions of bloated, bubbling colors about to burst, pinpoint corners, razor-thin edged lines. When they first moved from Chinatown to the Bronx, it was one of the first and most vivid things that stuck in his mind, the graffiti that seemed to patch and grow on any flat space in the city—on the sides of buildings, on buses and billboards, in parks, and on the sides of garbage trucks; even places he thought impossible to reach like the high girders and beams of the subway tracks, or over the sides of bridges and the expressway, where certainly life and limb had been risked. He imagined the artists, daredevils with bags of paint slung

over their shoulders, rappelling like mountain climbers.

He had asked his parents back then why people drew on the walls.

"Vandals," his father had said. "They should be arrested."

"It's disgusting," his mother said. "Someone should clean it up. It looks terrible."

Within a few weeks of opening the new restaurant, the metal gate they pulled down each night had been "bombed," a mad scrawl of swishing, swirling Technicolor tags and arrows. His father muttered and cursed, but his mother said, "Leave it. If we clean it, they'll just mess it up again. At least it's not on the windows."

But Tony did not think it looked terrible, then or now, and through the years as he saw more and more, to him it was all some wondrous blossoming, flowering fragments from a different world. In particular, he had loved to watch the trains float by, over and through the city, some splotched with bombs and throw-ups, others highly decorated, meticulously designed burners from top to bottom, end to end. The inside of almost every subway car was also marked and thoroughly tagged, as were the tops of the buildings that lined most above-ground subway routes. Sometimes, riding the train felt like a tour of fantasy landscapes and colors, but it was standing in the streets and on the sidewalks that Tony loved the most, where he could admire the passing trains, the unique style of each tag, the creativity of the phrases and messages, each series of train cars passing in rainbow phoenix streams.

When he saw the most elaborate designs, he tried to imagine the sketching and planning and practice it took to perfect each piece. A car painted with giant red-and-white Campbell's Soup cans, another that said "Merry Christmas" in calligraphic letters; whole trains painted in psychedelic splashes, or cartoon characters like Batman and Robin, Papa Smurf, Mario and Donkey Kong, Mickey Mouse and Donald Duck; warped images, naked women, the Grim Reaper and aliens, clowns and angels, ghouls and ghosts and monsters, runaway dreams. He admired the tags, the

writers' names carried from one end of the city to the other for all to admire and hate and see, tags he remembered once he was old enough to read and make sense of the style, names like "DURO" and "SEEN," "DONDI" and "TRAP" and "SKEME," so many others he could not decipher. Like a secret code among graffiti writers, the ability to read each other's work. And even now he would sometimes imagine what it must have been like back then to see your name, your work, winding its way through the city.

He remembered when the commercials began running on television, actors and athletes and singers talking about how bad graffiti was for the people and for the city. "Make your mark *in* society, not *on* society," that was the slogan, not just on television, but on posters and signs everywhere. Then, one by one, the beautiful train cars he loved began to pass as smudged and faded hulks, as if they had been melted down by liquid fire, their vibrant colors turned to ash, leaving the pallor of charcoal gray and dust.

Now, as he walked up the front steps of his school, he thought it had been years since he had seen a truly beautiful subway car. He felt sad that such art and originality had become only a striking memory.

Being in class did not bother him so much. In each classroom there were windows, and from some rooms he could spot pieces of the school's walls and roof that had been spray painted in days gone by and had not yet been washed over. He always tried to sit close to the windows, so no matter how dreary a class might feel, there was always light coming in that kept him awake, alive.

There was order and structure in the classroom, a general quiet, a teacher who everyone knew was in charge to some extent. Lessons to learn, exercises on the board, writing assignments, readings to discuss. For the most part, Tony felt that school went along pretty fast, unlike the free-for-all in the cafeteria or hallways, filled with blind corners and shadows from where someone (usually Victor Ramirez) might appear at any moment and try to knock his books out of his hands or trip him or hit him

in the face with a spitball. No one ever came to his defense, and he knew why—because he was one of the only Chinese kids in school. There were a handful of others that were older than him, but Tony only knew they were Asian from appearance, was unsure if they were Chinese, Japanese, Vietnamese, Korean. But what did it matter? No self-respecting upper-classman would come to the aid of a short, fat, dorky ninth grader.

The best thing about being in class (besides being insulated from the fray of the halls) was that when he got bored with a particular lesson or lecture on algebra or mitochondria, he could take out his sketchbook and draw. He wasn't sure if the teachers saw him and didn't bother to stop him (he was a straight-A student and knew there were perks that came with this territory), or if they were really so oblivious to his actions. Either way, he would slip the sketchbook and pencils out from his book bag and pick up wherever his drawings had left off the night before.

His favorite class these days was World History. It was his favorite not because it was right before lunch, and not because he loved history or the world; but because it was the only class he shared with Maria. She had a soft, sweet voice, olive skin, and big dark beautiful eyes; a smart girl who did not raise her hand to answer questions very often, but usually knew the answer when called on. The year before, in science class, they had partnered together to dissect a frog. Tony did most of the snipping and slicing, but when the project was complete and they both received A's, she looked at him, smiled, and said, "You did really good, Tony. Thanks."

These days he spent most of World History stealing glances at her. She would sometimes smile when she saw him, and other times she ignored him completely. He wished he could sit close enough to her to smell her perfume, wished there was a way he could impress her beyond his ability to cut open a frog.

As his history teacher, Mr. Reynolds, droned on, Tony opened his sketchbook and worked on his own tag. The subway trains were mostly clear now of graffiti, and he imagined being a part of graffiti's revival, a new

explosive campaign that would shock the city and revitalize the movement. Old graff heads from years gone by would return, along with a new breed of writers and artists who found ways to defy the city and the MTA, a way to neutralize the fences and dogs and police guarding the train yards. They would tag and bomb schools, businesses, apartment buildings, anywhere and everywhere they could find just a few flat square feet to work. But it would be accepted, celebrated even, no more raids and wars against graffiti writers, no more chemical washes on the trains. People would see the beauty and art and craft in what they did. Punks and toy writers whose work was sub-par would be excluded—graff heads would police themselves. They would no longer have to live and work underground. Society as a whole would embrace them.

So when the time came, what would his tag be?

"Mr. Cheung, are you with us?"

There was mumbling among the class as Mr. Reynolds walked over to Tony's desk. He slowly closed the sketchbook as Mr. Reynolds's footsteps drew nearer.

"Mr. Cheung, can you tell me what year the Magna Carta was signed and why this is so significant?"

Tony didn't want to look up, could feel the teacher's eyes boring down into the top of his head. He didn't know the answer, hadn't read the assignment, had figured he would read it the night before the test and get an A as he always did.

Then Mr. Reynolds was reaching down for the sketchbook, and before Tony could react, his teacher had scooped it up and opened it and was walking back to the front of the classroom. There were audible "ohs" and "ahs" coming from the class as Mr. Reynolds slowly flipped through each page. Tony sat with his head still down, his fists clenched in his lap beneath his desk, feeling a red, deep hatred simmering in his chest.

Mr. Reynolds was a tall man, coach of the baseball team, with close-cropped hair and a mustache and beard, all of it going slightly gray. But his

most distinguishing characteristic was the big mole on his cheek, and behind his back all the students called him "Mole Face" or "The Mole." Now Tony tried to will Mr. Reynolds to have a heart attack or stroke on the spot, or spontaneously combust into one giant ball of flame. Anything, as long as he would drop the sketchbook and give it back.

"'TICE'? Or is that 'T-NICE'? What is this, Mr. Cheung? Are these your secret superhero names?" Mr. Reynolds looked up and smiled; the class laughed. Tony thought he saw the mole growing, twitching on Mr. Reynolds's face. "These are some nice drawings, Tony. But you know, graffiti is illegal and somewhat out of style, don't you think? Jeez, even I know that. You ought to catch up with the times. Try dancing, or rapping, right?" Mr. Reynolds raised his hands and shrugged, then looked around the classroom for approval. They were all laughing at Tony now, again. Mr. Reynolds handed the book back to Tony and said in a low voice beneath the din of the class, "Get your head out of the clouds. Next time you get detention."

But all he could see was Maria staring at him across the room, covering her mouth and laughing with her friends.

Later in the cafeteria, sitting by himself, he felt a poke in the back of his head. It was John, a white kid who had transferred this past year and who was in most of Tony's classes. Tony closed his sketchbook and slid it back safely inside his book bag.

"Yo," John said, "that was messed up." Short like Tony, but skinny as a reed, he too often suffered the wrath of Victor. With his tray, he sat down next to Tony and spiked a fork into his mashed potatoes.

"Yeah, well. I just gotta be more careful."

"But he didn't have to do that," John said. "People screw around in his class all the time, and he's gotta pick on you? I'll bet you're the smartest kid Mole Face has in any grade."

"At least I didn't get detention," Tony said. Then he saw the expression on John's face, but before he could do anything Victor had reached over

and grabbed his book bag off the table and was rifling through it; seconds later, he was holding the sketchbook up in the air like a prized trophy. Already Tony could feel the crowd gathering around them.

"Chunk, man, you think you a graff head or somethin'? Hell, even Mole right about this one. That shit is dead, son—look at all this!" Victor flipped rapidly through the pages of the sketchbook as his cronies giggled and pointed.

"Give it back, Victor." Tony heard his own voice, how small and weak he sounded.

"Yo, you rollin' wit a crew, Chunk? You got some homeboys you go bombin' wit?" More laughter growing. "Let me tell you somethin', Chunk. You ain't black, you ain't Latino, and you ain't down wit *nobody*. Way you dress, tryin' to wear what we do, act like we act. But you're *played*, kid—that's what I'm tryin' to tell you! You just a fast-food fried-rice-smellin', punk-ass chinaman. That's it. Come to school smellin' like lo mein all the time."

Victor's smile had turned into a snarl. "Go cook me some chop suey, man. Go iron me a shirt." He grabbed a page from the sketchbook and ripped it out, crumpled it into a ball, then threw the book at Tony's feet. The kids around them now were howling. John had disappeared.

Tony stood, staring back at Victor, felt a boiling in his gut, in his chest, the inside of his head hot and swelling behind his eyes, his lip trembling. Was that Maria's face he saw in the circle of bodies around them? Was she still laughing? Was it even her? What difference did it make—she would hear about this, if she were not witnessing it herself. She would know how badly Tony had been punked—again. And he suddenly felt that any kindness she might have shown him in the past, or any friendly gestures she might demonstrate now were nothing more than pity, had always been, and always would be.

Tony picked up the sketchbook and put it back in his bag. He turned to face Victor; his nose came up to the middle of Victor's chest. Looking up he

could see the whiskers of Victor's mustache.

"Don't ever touch my stuff again," Tony said.

The laughter stopped. He saw the incredulous look in Victor's eyes, the features of his face flatten.

"What you gonna do, Chunk? Hit me wit' some kung fu? You gonna karate chop my ass?" Victor pressed two fingers into Tony's chest and pushed him back a full step.

"You lost your mind?"

Victor was leaning over him now. He thought at any moment he was going to get walloped, driven into the ground or over the table and into the wall by one sweeping devastating punch. For all the times he had been called "chink" or "Chunk" or any other name, Tony wanted to shoot back and call Victor a spic or wetback or something else he knew would strike a chord. It would guarantee his physical destruction, but it would also show everyone that he was just as mean and not afraid. But he didn't feel it, didn't hate in that way. They would just be words, and for words he would get pummeled, and he knew that wouldn't prove a thing. So he said nothing, and Victor just stood there breathing down on him. But all the laughing had definitely stopped.

"Just leave me alone," Tony said, "and don't touch my stuff."

Before a teacher could come break up the crowd Tony had walked out of the cafeteria, and out of the school, and into the street where he had never felt more alive, more angry, and more alone.

CHAPTER 3

At the restaurant, his mother asked, "What is wrong with you?"

"Nothing," he said.

"You've been daydreaming since you got here, and the phone is ringing off the hook. If you're not going to help, then just go home."

"Fine, I will," Tony said, jumping at the chance to leave the restaurant early, which almost never happened.

"And make sure you do your homework. Don't waste all your time daydreaming and drawing in that book," his mother said.

As he left the restaurant, he could hear his mother asking his father in Chinese, "What is wrong with that boy?"

But that was exactly what he planned on doing when he got home—he was going to practice. He still felt acid in his stomach, a light tingling burn in his head and fingers. He wished he were big enough to fight Victor, face to face, hand to hand, punch and kick and choke and slam, throw all he had at him once and for all. But Victor was so much bigger and stronger, he knew it would be suicide. He felt proud of himself for at least standing up for himself, for walking away this one time with his head not bowed in

absolute defeat. Yet he understood that it was not even a battle he had won; at most it was a moment, an instant, and in the greater scheme of things it meant very little, if anything at all.

So what could he do? Would he ever be able to stop the abuse and earn some respect? Even Mr. Reynolds was in on the act now. If the teachers turned on him too, then his life would surely be nonstop hell.

On his way home, he stopped at the hardware store. The owners were an old man and woman who knew him from the restaurant, and each time he went in he always smiled and bought something small—a box of steel wool or liquid soap, something cheap that he could later bring to the restaurant without being detected. In the process of wandering through the store, with the old man and woman behind the counter constantly bickering at each other, he would stuff two, maybe three cans of paint in his book bag, depending on how much space he had inside, then saunter up to the counter, pay for his box of steel wool, and leave.

Today, he bought a small bag of thin rubber gloves and air filter masks. "Painting the restaurant," he said, and the old man and woman smiled at him and nodded.

Back in the apartment, he figured he had only a few hours before his parents would be home. He took the staircase up to the roof of the building. It was not a huge building, only six floors, with a few dozen units altogether. Most of his neighbors were Puerto Rican, and in the summer they would have barbecues out on the sidewalk in front of the building, spreading up the block and into the street. The children played games and had water fights, and on the hottest days it felt like the whole building, if not the whole neighborhood—except for Tony and his parents—had been invited to the party.

It didn't bother him too much because he knew that his mother and father didn't eat barbecue and didn't like salsa music and would have nothing to say to the neighbors. Not that they disliked their neighbors or the neighborhood—they had moved to the Bronx to start a business, and

the restaurant had done well enough for them to survive through the years. They were simply quiet people who kept to themselves. Tony had never seen or heard either one of his parents trade more than a smile or "hello" with a neighbor in the elevator. They had never gone next door to borrow sugar or salt or a cup of oil for cooking or detergent for the wash if they ran out (they never ran out). When he was very small he used to play with a few of the kids in the building, but as they got older it stopped. He wasn't sure if it was because he spent more time with his parents in the restaurant (why pay a babysitter when he could be perfectly safe and content with them?) or if he had gotten into trouble of some kind and his parents had told him not to play with the other little boys. By now it didn't matter, as he was in high school and the rules of acceptability were out of anybody's direct control. But Tony couldn't help the feeling that this was how his parents had orchestrated it, had wanted it all along.

But it wasn't what *he* wanted. They had never asked him what he wanted.

On the roof, he went to a corner with his new cans of paint, added them to the sack that he kept hidden under a loose panel covered with random bricks and stray scattered clothing that he kept carefully arranged to look like some discarded worker's pile. From the sack he pulled out a couple cans of colors he had been tossing around in his mind—red, black, and gold—careful not to spill his collection of lighter-melted and finger-molded spray caps that he used for different effects. The roof was black and the walls had been painted over a few years ago when the new roof was put in, so to Tony it felt like being surrounded by a three-dimensional brick canvas. He kneeled down behind one of the big metal vent hoods to avoid being spotted and began to outline his design. The final product, he knew, would be bigger, but this small patch of brick would have to do. There was only so much wall up there and he needed to use it wisely.

He felt the warm sun on his back, heard the sounds of birds overhead and the city beneath him. It felt good. He liked being able to work and actu-

ally see what he was doing; unlike all the times he had snuck up to the roof in the past year to practice, unbeknownst to his parents, when he had to guess and squint in the moonlight, having to wait until the next day or even the day after to sneak up to the roof during sunlight hours to catch a quick glimpse. Even so, working at night was one of his favorite things—he loved the secret feeling of sneaking out of his room and apartment when he could hear both his parents snoring, the thrill of doing something dangerous, illegal, seeing the mist of paint and spray against the moon and black sky.

Now the shapes seemed to flow from his brain through his arm, into the spray can, as if some higher power had suddenly taken control. He felt the anger and panic from earlier in the day as he had faced down Victor; but the more he thought about it, the angrier he got at Mr. Reynolds. John was right—did The Mole have to go that far? Did he have to make such a show of it? He had never acted up before, so why the spectacle? Why make an example out of him? If Mole Face hadn't done that, then Victor probably wouldn't have heard about it and would have left him alone. So he blamed Victor and The Mole equally, at least this one time.

After each swoop and swirl of the paint can, Tony stepped back and looked over his shoulder and around the roof to see if anyone was coming. Then he turned back to his work to assess. Where would he put the next stroke? Where did he need more fade, or more edge, or more color? Or was there a shape growing somewhere that needed to be brought out, expanded? Then he thought of what Victor had said and knew that he was right: he wasn't a graff head, a graffiti artist, a writer, whatever you wanted to call it. He had no credibility, no crew. He was a kid, and graffiti was just something he liked, a safe hobby. Sure, he had seen movies and read a few books and magazine articles. He knew the lingo. He knew a few names of old-school writers. But he would never be so bold as to call *himself* a graffiti writer. For that you needed dedication, commitment. But when and where would he find the time, between school and working at the restaurant? Afternoons like this came few and far between, so he had to cherish it, but he knew that if he

were to take his art seriously, it would be something for which he would have to make the time. And he wasn't exactly sure how he could do that.

He looked around the rooftop at the few pieces he had done over the last year, mostly practice tags in various makeshift styles that he had not gone back and covered up himself. Then he looked back at the piece he was working on now. He liked it. He wondered what Maria would think if she ever saw his work. Would she admire it? Would she think it was silly and stupid? Would it make her want to talk to him, or at least not ignore him as often? Would she ever laugh at him again? He wished there was a way he could talk to her about what he saw in his drawings, in the world, in the graffiti that was left that had not yet been dissolved or erased or scrubbed. He wished he could explain that he was more than just the smart fat kid that everyone picked on, that he actually saw and felt things in a way that maybe no one else did, at least not anyone else around him. But he knew he didn't have the voice, and that he would never have that opportunity unless he created it for himself.

He looked back at the fresh paint on the wall: his colors, his creation, his identity and name. It was not the entire broad side of a subway car that would travel all the boroughs of the city, but it would become known, at least for an instant, very soon.

It was John who told him that the baseball team was going away for the weekend, a tournament of some kind. Tony had not even been aware that the team was any good.

"They are," John said. "It's a regional tournament."

"Why are you so into that crap?" Tony asked him. They were at lunch again, sitting just the two of them at a table on the far side of the room, away from the main cluster of kids.

"What crap?"

"You know, the baseball team, the football team. I mean, you like the Yankees, fine. But the school teams, they don't care about you."

"Well, whatever, Tony. You like what you like, I like what I like."

"Alright, alright," Tony said. He felt bad for picking on John. They both had enough abuse to worry about from others. He said to John, "So what, they go away somewhere? Like Brooklyn or something?"

"No, it's the whole weekend. I think they're going upstate. I tried talking to Mole Face about helping out the team and stuff, but he was basically like, 'Yeah, maybe you can watch my car while we're away.'"

"What the hell does that mean?"

"They take a bus and leave their cars in the lot."

"They leave their cars in the lot? At school?"

"Yeah," John said.

"What kind of car does Mole Face drive, you know?"

"A new one, a big white one. I seen him in it leaving school."

That Friday he stayed late, acting like he was doing research in the library, but mainly because he could see the faculty parking lot from the main library window. Tony watched as parents dropped off their sons, and the coaches pulled up in their cars, Mr. Reynolds driving a big, new, white car just like John had said. Then they all boarded a bus and Tony went to the restaurant, where he took orders for four hours and then went home and went to bed.

The next day was spent at the restaurant again. During the slow hours he did his homework at one of the tables in the front of the restaurant. He went down the block to get pizza for lunch, watched the old men on the corner in front of the bodega playing dominoes, then went back to the restaurant and took orders and helped take stock in the cooler and all the other little things his mother ordered him to do. He didn't complain. He tried not to mope. He wanted his parents to be happy with him, satisfied and off his back for once.

"Why are you in such a good mood?" his father asked in Chinese.

"I dunno. School's almost over."

"Yeah? You get good grades again?"

"Of course, Dad."

"Of course, of course," his father said in English. Then he said, "Don't get cocky."

After closing for the night, they went home and had dinner, and Tony ate only a small serving of sliced beef, some rice, and the rest vegetables. His mother didn't say anything but he could tell from the look in her eye that she was pleased by this. His father, oblivious as always, just ate and then sat in front of the television, falling asleep soon after. When he had woken them off the couch and sent them to bed and cleared the dishes from the table (their nightly routine), he went to his room and waited. He did his exercises. Looking at himself in the mirror, he flexed and thought he could see a line of definition forming in the back of his arm where his triceps was supposed to be. His stomach, he thought, looked a little flatter, less jiggly. Or was it his imagination? He poked his head out to listen for his parents. Through their bedroom door he could hear them snoring. But still he waited another half hour just to be sure.

It was past midnight when Tony began packing his book bag. He stuffed the rubber gloves and air filter masks in, but left his sketchbook on his desk. He wore a black T-shirt and jean shorts and his old sneakers that had no treads left on the soles. He had snuck out this late before, but only to go up to the roof, and even then he had devised alibis in case he ever got caught: he thought he heard people on the roof trying to break into an apartment, or he thought he had heard something big and heavy fall, or crash land, on top of the building. Use his "daydreaming" to his advantage, his active imagination.

For this he would have no alibi, and yet he was not afraid.

First he went to the roof to retrieve the cans and spray caps he needed. Four cans, he figured, would do the trick. Then he walked as slowly and as noiselessly as possible down the staircase, nearly tiptoeing all six flights, to avoid being heard or seen by anyone in the elevator. By the time he got to the ground floor and out the door, he was already sweating and out of breath. Taking the backstreets on his way to the school, he looked up at the

houses and buildings around him, how ominous and disfigured they seemed in the dark. He saw lights on in some windows, heard radios playing, people chatting, cars driving by on the avenue. There was a solemn quality to the streets, restlessness lurking. Yet as he walked he felt taller, skinnier, faster, as if he were a different person in the night.

When he reached the school he knew exactly how to get in. There were big holes that had been cut and pulled and bent through the bottoms of the chain-link fences, used to get in and out of the basketball court yard and onto the playing fields in back, or just to get into the parking lot to have a place to hang out in a wide space, where neighbors would not be as quick to complain and police would be less quick to respond. Once inside, he found the faculty parking lot. Two of the four lamps in the corners had burned out, and someone had told him once that the security cameras perched on top of the fences around the school didn't actually work. He wasn't sure if this was true or not, but he thought it was definitely possible that the cameras were just a sham, a guise, kind of like the Plexiglas in his parents' restaurant that was supposed to be bulletproof.

He saw The Mole's white car shining in the moonlight, a big Lincoln Town Car with tinted windows, glossy black tires, and a buffed finish so deep it seemed to glow. He looked around the lot. There was a small path on which security often drove their little golf cart-type buggies when patrolling the grounds, but they made a whirring sound that Tony didn't hear now as he squatted next to the car and pulled on a pair of rubber gloves and an air filter mask.

He started on the lower half, on the panels. He didn't need his sketchbook. The vision was so clear, so perfect in his head, and now he made adjustments and improvised only for the size of the car, adding and filling in with background strokes and shapes and designs as necessary, freestyling. He took glances at his watch—he wanted to be fast. Within a few minutes he had finished one side and had worked his way around to the front hood. Here he took more time, wanted to be accurate, precise. When

he heard a sound he would squat down even farther, or tip to his elbows and knees and wait. Then he would reset himself and continue, sweating more and breathing heavier. Soon the hood was done, and he swung around to the passenger side, which he did faster because the clock in his brain was telling him that he was running out of time. The passenger side, he thought, would be the sloppiest, but that was okay. As he finished each can he tucked the empties inside his book bag. He imagined he was in the rail yard of the 5 train, propped up between two train cars side by side, climbing the side of one to bomb the other, all the while staying hidden, dodging security guards and dogs and cameras, his senses quick and alive. Finally he came to the trunk, where he threw up his tag, his final mark.

He didn't take the time to sit back and admire. He walked around the car to make sure he had not dropped anything that might give him away. He felt electric, on fire, like a swarm of bees buzzing through his veins. He looked at the school, realized he still had a little less than half a can remaining. He had never been inside after dark, after all the people had left, had never roamed the empty halls. Would it be just as horrible a place without all the bodies, all the voices around him? He wanted to find out. He kept an eye out for security, an ear open for the patrolling buggies, but heard nothing. Did the school not have security on weekends, at this hour? Maybe it was only one poor guy who had fallen asleep in his buggy on this humid pre-summer night. Then Tony found a side door ajar, pulled it open, and he was in.

He looked at his watch—it was past one in the morning. He knew that if his parents woke up now they would go to his room and find it empty. The police would be called, and God only knew what kind of calamity would follow. But he could feel that his parents were still asleep, a kind of sixth sense of danger that had not yet been triggered. Then he saw a clear spread of wall by the main entrance of the school, a wall that every student in the school had to walk by every single day.

CHAPTER 4

Monday morning, as Tony walked to school, he knew he would have to rush to beat the homeroom bell. It was sunny out, getting warm already, a light breeze rustling the leaves of the few trees that lined the streets. As he came up the block, Tony could see a crowd gathered around the school's parking lot fence. He stopped for a moment, thinking it was a fight or an accident, but he didn't hear shouting, didn't see people running and flying around, didn't sense that urgency or danger. There was a police car parked alongside the curb, but this was nothing unusual.

Against the fence he pushed his way in between two kids to get a view. Two policemen were standing next to Mr. Reynolds, one of them writing things down on a notepad as The Mole spoke, but Tony could not hear what he was saying. He kept pointing at various sections of his car, and every few seconds Mr. Reynolds would scratch his head and look around at all the kids hanging on the fence, peering in on him like a zoo animal. The principal, Mr. Johnson, kept circling the car over and over again.

Tony listened to the boys around him talking.

"Yo, that is *crazy*, son."

"No joke."

"For real. That shit is dope."

"Yo, check out Mole. My man is *heated.*"

Tony could hear other kids giggling, laughing, whispering, and murmuring with silly half-smiles and wary looks in their eyes. Asking, "Who?" Asking, "How?" As he surveyed the situation, he felt a cramp clenching up his stomach, a tingle in the back of his head creeping down his neck and spine. His hands were clammy. He looked around, but no one seemed to notice him.

The principal stepped back as Mr. Reynolds and the two cops did a slow walk around to the back of the car. Now Tony could see the hood, the gleam of new paint in the sun against the car's original white. He saw the big bloated caricature profile of Mr. Reynolds, his bushy cartoon eyebrows and big red nose, the mole on his face pulsing and sweating like a swollen sore, but with the stitching and design of a baseball; his mouth agape, swallowing what could have been a baseball bat but was more likely a penis, with two testicles (also painted like baseballs) dangling against the bony ridge of his chin.

Down the length of the fence, Tony saw Maria looking on with her girlfriends, all of them laughing, a couple of them bent over, holding their stomachs, covering their mouths. As she giggled, Maria's hair swayed in her eyes and around her face, two deep dimples forming in her cheeks, and Tony's stomach relaxed just for a moment.

He looked at his watch, left the fence, and headed inside, where he could immediately feel the buzz of rumor and scandal, the electric vibe and frenetic voices that filled the hallway. As he made his way to homeroom, he saw another crowd gathered in front of the wall by the main entrance. There were a couple of janitors and a few teachers in front of the wall trying to cover it up with construction paper, but they couldn't because the tape was too weak to hold up the big sheets they were trying to use. The kids pressed even closer to look, and Tony fell into the flow of the crowd, feeling nervous, jittery, an itch now spreading over his chest and

back. Pressed in between all these kids it was hard to breathe, traces of sweat dripping down the sides of his face. Then he was close enough to see very clearly the figure he had drawn.

Above the bubble-shaped, muscle-bound torso was Victor's disfigured cartoon head, the features warped so that the head looked more like a watermelon with a puff of nappy hair; big, empty doe eyes; and a buck-toothed, dopey grin. Cartoon Victor's wide shoulders tapered down into a miniscule waist, wearing tiny tight shorts like a bodybuilder with bare skinny sticklike legs. In one hand he held a football, and in the other hand dangled a report card that read, "Math: F; Science: F, English: F, Gym: A."

At the foot of the caricature was his tag: TERA 180.

Again, Tony listened to the voices around him.

"Yo, that is messed *up*."

"Whatever, yo. Victor always actin' like he's all that."

"'TERA 180'? Yo, kid got a tag and everything."

"Tag, whatever. My man got *balls*."

"And a bull's-eye on his back. Whoever done this gonna *pay*, son."

Tony turned and began to walk away, could feel his heart leaping in his chest as he scanned the crowd for Victor or his gang of cronies or anyone else that might be looking at him suspiciously. The homeroom bell had rung, but it seemed like everyone was still either coming in from the rear entrance next to the parking lot, or milling around the front doors, gasping, pointing, laughing at Victor's near-naked, class-failing, muscle-bound likeness. For a moment, Tony stood to the side just to watch, as if he were floating above it all. He thought about The Mole's bulging eyes and beet-red cheeks and sputtering lips as he talked to the police, the teachers scrambling around the halls trying to get students away from the mock-image of Victor and back into their classrooms. He had seen and heard the awestruck reactions, knew that none of the students had ever seen anything so blatant, so bold, so daring, and because of that they felt something for the feat, the act.

Admiration. Respect.

But he wasn't sure how good he should feel at that moment. Yes, he had gotten the reaction he wanted, but still, no one knew it was *his* talent, *his* work. How proud could he be, still slinking around the halls, one eye perpetually on the lookout for Victor? That kid was right—if Victor found out, Tony would have a bull's-eye on his forehead and his back. So maybe it would be for the best if people never found out. This way he would be able to cherish and relish his work the way the old school writers did when they saw car after subway car that they had bombed and burned gliding the rails, decorating so many scenes of the city. Maybe it wasn't about personal recognition, but the affect your work had on people. In his heart Tony would know, and maybe that was all that mattered.

As he walked toward homeroom, he wanted to jump up and down and smile and howl and beat his chest like a victorious warrior. But he needed to act normal, not draw attention to himself. That was okay; in his brain and heart, it was his birthday and Christmas and the Fourth of July all rolled up in one. He felt light and airy, as if he might float away on a cloud. Still, he could not shake that tugging feeling in his chest, could not stop thinking about the fact that he had accomplished more in one day as a symbol, a tag, than he had as a person in his entire life.

In homeroom now, the students were slowly milling their way back into the classroom. Tony took his usual seat as everyone around him continued to whisper, heard them repeating his name: TERA 180.

"Alright, sit down, sit down," his teacher said. But before the teacher could begin roll call, the school secretary's announcement boomed over the loudspeakers: "Tony Cheung, please report to the principal's office immediately."

In the main office, he sat behind the front counter, just outside the principal's door. That fluttery butterfly feeling in his stomach and chest was gone now. The office secretary was in the midst of shooting Tony a long glance, when he heard Mr. Johnson's thundering voice.

"Is he here? Send him in." The secretary looked at Tony and nodded.

He walked into Mr. Johnson's office and was struck by the smell of old dusty books. The Mole was sitting in a chair with his arms and long legs crossed, his face still red with anger. Mr. Johnson—a big, burly man with a head of gray hair, accented by a pink, cratered nose—was standing behind the desk. He pointed to the empty chair next to The Mole. Tony sat. Mr. Johnson sat. He could feel both men boiling, like they were both physically expanding around him, the heat and pressure of their presence about to burst. Mr. Johnson let out a deep sigh. Then he said, "Tony, you heard what happened?"

"Um...no. I don't think so."

Mr. Johnson said, "Looks like someone decided to vandalize Mr. Reynolds's new car, as well as the wall by the main entrance. You're telling me you know nothing about this?"

"I saw some people looking just before," Tony said, "but I don't know." The nervous itch on his chest and back now felt like fire ants spreading across his skin. He was still sweating. It was hot in Mr. Johnson's office even though the air conditioner was blasting.

Mr. Johnson said, "Tony, let's not play games, because I'm going to get the tape from the video cameras and that will tell me exactly what happened. Save yourself the trouble of being a liar on top of everything else. I'm giving you a chance here to earn back some good will."

Tony thought about it for a second. Did they really have a tape from the cameras? Was he bluffing, trying to intimidate him? Mr. Johnson stood and went to the office door, where he shouted to his secretary for two cups of coffee. Mr. Reynolds had still not said a word, nor had he taken his eyes off of Tony. In his mind, Tony could see The Mole and Mr. Johnson scheming like detectives from a television show, playing good cop/bad cop.

Mr. Johnson returned to his chair and said, "Mr. Reynolds told me he saw your sketchbook the other day, that he recognized the drawings. The style. Do you have your sketchbook with you?"

"No," Tony said.

"Can I take a look in your bag?"

"Sure." He handed Mr. Johnson his book bag, knowing that he had left the sketchbook at home. Mr. Johnson looked inside, then slid the bag back to Tony.

"Look, Tony, we're not out to get you. So why don't you just tell us what's going on? It'll make things easier for all of us."

Tony sat with his arms crossed, head tilted down. He could smell the two men's collective breath (coffee and cigarettes) filling the room, choking him out, smothering him.

"I want to speak to my lawyer," Tony said. He couldn't stop himself from smiling.

Mr. Johnson sighed again. He said, "I'll do you one better. Let's call your parents instead."

He spent the next hour sitting in a chair outside Mr. Johnson's office door, could hear the two men grumbling. The secretary popped in and out of the office at Mr. Johnson's beck and call. Tony tried to come up with reasons to sue the school: for holding him out of class, depriving him of his right to public education, for mental and emotional distress.

At one point, Maria came into the office and handed the secretary a handful of papers. She saw Tony sitting there, and Tony could not help staring at her, her long hair and mocha skin and big, dark beautiful eyes. He wanted to reach out and grab her, sit her down, tell her what he was going through. Yes, it was he who had bombed Reynolds's car and dared to call out Victor in such a humiliating and public way. Yes, he had planned it that way, all by himself, and yes, he was now in some deep shit. He wanted to know what Maria thought of it, of him, but all he could manage was a meek smile and limp wave.

As she waited for the secretary to stamp the papers, Maria turned to Tony and silently mouthed, "Are you okay?" Tony nodded. She mouthed,

"What happened?" and Tony shrugged and smiled. The secretary gave the stamped papers back to Maria. Maria looked at Tony before she left. "You crazy," she whispered with a smile.

Later, a man Tony had never seen before walked in and handed the secretary a small box. The secretary looked at Tony, then knocked on Mr. Johnson's door and brought the box in.

His parents showed up soon after. His mother fixed him with a glare, her eyes red and wide, her lips pursed. His father's face was red and oily with sweat, the muscles in the side of his face twitching. Neither spoke to him. The secretary showed them inside Mr. Johnson's office. He heard Mr. Johnson talking, did not hear his parents reply. This went on for several minutes. Then Mr. Johnson shouted, "Lorraine, tell Tony to come in."

When he walked in he saw his parents and Mr. Reynolds sitting in a semicircle in front of the desk. There was a VCR and television on a cart next to Mr. Johnson, and Tony's sketchbook was laid out on the desk, two pages overrun with doodle after doodle of the tag "TERA 180," looking small and insignificant, like a cluster of scratches.

"The cameras," Tony said. "I thought they don't work."

"But they do," Mr. Johnson said.

They all sat in silence for several moments. Tony could feel his heart pounding and his stomach grinding, like his body was eating away at itself. He wanted to talk, to defend himself, but his throat felt clogged as if stuffed with a rag. His eyes stung, and he thought he might cry. Instead, he crossed his arms and dipped his head and waited.

Mr. Johnson asked, "What does 'TERA 180' mean? Is it a gang sign?"

Gang? Were they accusing him of being a gang member? The twisting in his stomach screwed up a notch. It was too much. From abused geek to gang member? Did they believe their own nonsense? Were they all that clueless?"

"Tony," Mr. Johnson said, "if you're involved with others, you need to tell us. You're in enough trouble. Don't make it worse."

The fatherly tone, so different from before when it was just he and Mole Face. What an actor, Tony thought. What a clown.

"I'm not in a gang," Tony said. He could feel his parents' eyes boring into him. He wished they would say something, but then again, he knew he would hear plenty from them when he got home—*if* he got home.

Whatever, Tony thought. *I've got nothing to lose.*

"TERA 180 is my tag. It's *me*, okay? I did it. I did the car, I did the wall."

He could feel an immediate physical release inside the room, as if they had all been holding their breaths waiting for him to confess. It felt good to say it, to take ownership of the work. Besides, after the loudspeaker announcement, then seeing Maria in the office, he figured the whole school already suspected him; there would be no hiding it now.

"Okay," Mr. Johnson said, "but what does it mean?"

Tony almost laughed. It was like a valve or plug had been pulled inside of him. The pressure was gone. So was the fear. He felt loose, liquidy inside. His parents were staring at him as if they did not know who he was. They all watched him, waiting for him to explain.

"TERA is short for 'terror.' We live on 180th and Vyse. There's no gang, no one else. It's just me. I did it. That's it."

CHAPTER 5

On the walk home, he felt like a prison inmate being led to his cell. His mother was speed walking, arms pumping, talking to herself, while his father lagged behind, hands clasped behind his back, head tilted down, brow furrowed. Tony walked between the two, pacing himself so that he was not too close to either one of them.

As soon as they got through the door, his mother said, "Go to your room. I want to talk to your father." Tony did as told. He sat on his bed, waiting, listening to the sound of the subway rumbling by. He felt itchy, sweaty, hungry. His first impulse was to draw, but they had taken away his sketchbook. He imagined Mr. Johnson and The Mole combing through it page by page, photocopying incriminating evidence. That was okay—there was nothing too great in there anyway, all old stuff that he had long since outgrown. His work was so much better now. He would get a new book and start over.

He wondered if word had spread, what the kids were saying now that they knew what he had done. He imagined Victor chasing his friend John and smashing his frail white buddy into pieces because he couldn't get his hands on Tony. He wondered what his parents were going to do, if they

would flip out screaming and yelling, maybe even hit him; he had not been spanked since he was eight or nine years old, but still, a beating was possible. No matter what, he told himself that he was ready, mentally prepared. All along he had known what he was doing, known there was a chance he might get caught. But he also understood that he had never been in this kind of trouble before.

When the phone rang his mother answered.

"Hello? Yes...yes...uh-huh...Understand, thank you...I know, he is good boy, yes....Yes, I think good idea, thank you....Yes, right." Then she was quiet for a few moments before she said, "I think so...Okay, I talk to my husband. We do what you say, yes....I think fair, yes." She ended the call, saying, "I know. He very sorry. No more trouble. He is good boy. Okay. Thank you, sir."

Afterward, he heard his parents talking in low voices. Then there was a knocking on his door.

"Come out here," his mother said in Chinese.

His parents sat on the couch, and Tony sat in a chair pulled up in front of them.

She said, "The school called."

"I know. I heard."

His mother sighed. She told him that he was not being expelled because he was a straight-A student with no marks against his record; and that Mr. Reynolds, after much discussion and negotiation with Mr. Johnson, had agreed not to press any charges against him.

Tony sat there watching his mother's lips moving, hearing the sounds coming out of her mouth. He felt empty, a little silly, didn't know what else he was supposed to think or feel. He had expected, if caught, to do a few weeks of detention, maybe even a short suspension, but the possibility of having charges pressed against him had never occurred to him. He realized that he had truly believed from the beginning that he was going to get away scot-free. But if that had been the goal, then why the tag? Why leave

any kind of trace or name? He felt the consequences of his actions whooshing past him like a speeding car that had nearly run him down.

His mother continued.

"But," she said, "you are being suspended from school for the rest of the year." She looked down at her feet, and her shoulders seemed to slump. His father crossed his legs and put a hand over his face.

Suspended for the rest of the year? He felt soft and heavy and numb, as if his flesh had turned to clay. Maybe that speeding car had not missed him entirely just yet.

His mother said, "You also have to pay back your teacher for what you did to his car, and you have to pay back the school for painting on the wall. So you are going to come to work with us every day. Anything you make at the restaurant will go to paying them back."

"Everything I make?" Tony said in English, half-rising from his chair. "How am I supposed to...I mean, you can't...you can't take all my money!"

His father leaned forward with his elbows on his knees and said, "Lower your voice."

Tony sat back. He said, "I'll get left back. I'm going to fail all my classes."

"No," his mother said. "Someone will bring you your assignments. You'll do the work at home, and go to school to take your tests. The principal will watch you. This way you won't miss anything." A pause, then his mother said, "You should feel lucky. This is a special arrangement. The school is being *very* fair. If it was up to me, I would have kicked you out for good."

"Of course you would have," Tony muttered.

He saw the look change on his mother's face, her eyes suddenly wide, her mouth dropping open. His father stood slowly. The air seemed to freeze around them, stuck in a time warp. Then his mother's face twisted into a red, screaming mask.

"You have the nerve to talk back to me? You should be apologizing and thanking your teachers. After the disgusting...those horrible pictures! I don't understand what I did to have a son like this!" She looked at her husband and said, "We're cursed. What did we do?" His father was now standing by the window across the room, looking outside. His mother went on. "We work so hard for you to have a good life, so you don't have to suffer like we did. But you turn around and disgrace us—humiliate us! You make us all lose face. You're fat and lazy and spoiled. It's my fault. I'm a bad mother. God, I wish I were dead for raising such a bad son."

"It *is* your fault!" Tony screamed. He stood holding his head in his hands, thought his brain was going to explode. "You think I'm spoiled? All I do is work! I go to school, I work, I go to the restaurant, *I work*. And I don't get any credit for anything. I just get picked on all the time. 'Your grades should be higher. You should exercise. You're lazy, you're fat.' I eat at the restaurant every day, and you wonder why I'm fat?"

"Your father and I aren't fat," she said. "If you exercised, showed some self-control..."

"When am I supposed to exercise? I'm always at the restaurant, and everything is fried! My god, don't you see? I have no life, I have no friends, and it's your fault! Now I do one thing and I'm a bad son? *You* made us live up here where everyone hates me because all we do is serve fried rice! I'm a chinaman, I'm a chink, I'm just one big walking joke. You have no idea what it's like to be me for one day!"

He did not see his father approach, did not see his father swing his arm or even feel the impact of the slap against his face, only felt the turn of his head and realized his father was standing right next to him, glaring. He heard in that instant his mother's gasp. For a few seconds they stood motionless. Then Tony rubbed his face. He felt his eyes burn, the sting of the skin on his cheek where he had been hit. His breaths became short, choked. He saw his mother's eyes go soft, and she stepped forward to hug him, was already crying, but Tony shrugged away and stepped past

her. He would not look at his father. He heard them both talking, but it was gibberish.

He went to his room, slammed the door, locked it, and propped his chair against the door handle. He threw himself face down on the bed, muffling the sound of his parents talking as best he could with a pillow. His chest swelled as he took deep convulsing breaths. Was he having a heart attack? Good, he thought. He wished he were dead. Not because he had a bad mother and father—he knew this wasn't true—but because of all he had done and all he had hoped for, and this one time, all he had tried. He had succeeded for those few glimmering moments of notoriety and scandal, but again he had failed because he could not change who he was.

They called him Chunk, and that was what he felt like—a chunk of flesh, of rotten meat, of fat and flab that no one could like. Not even his parents, even if he got good grades and did everything he was asked. He cried because he hated being short and fat, hated being Chinese, hated living in the Bronx, hated his parents for moving them there and working so much and making him work in the restaurant instead of letting him be a boy like everyone else. He hated Victor; he hated his teachers. He even hated Maria, blamed her for being beautiful, for teasing him by being nice to him sometimes in her gentle unknowing way, for making him think that there was even a chance she might someday consider him normal. But he was not, and he cried hardest and longest because there was no way to escape his person, his character, and crying was all he had the power to do.

He expected things to get worse after the fight with his parents. His father's slap had surprised him more than it had hurt him, so now maybe the flood-gates were open. If things escalated far enough, there was always the possibility he could get hit again—and that he might even try to defend himself. But this did not happen, and during the next few days Tony and his parents did not speak to each other. He woke to the sounds of his mother making tea in the morning, the whistle of the kettle, the clink of the

teapot and cup. They walked to work, and he helped his father pull up the metal gate, helped the cook refill and heat up the fryers and turn on the fans and blower and prepare the rest of the kitchen. Then, right around eleven, the calls would start coming in and he would help with the phones and bagging orders.

When he left the restaurant to get pizza, his mother did not ask him where he was going, nor did he tell her. The pizza man still called him "gordito," but Tony did not respond. He ordered only one slice and a cup of water, and the pizza man curled an eyebrow at him. After lunch, he would look at his watch and wonder what was going on at school. It felt so strange not to be there, but he could not say that he missed it. It was simply…different. Instead of doing the same things at school every day, he did the same things at the restaurant every day. He tried not to think about each hour's salary going into The Mole's pocket, about the car and the wall and Victor, but it was impossible. When he retraced his steps and tried to determine how he could have protected himself more, it felt like it had all happened a long time ago.

He was not surprised when John showed up at the restaurant with his assignments. He wore all black, even in the hot sun, his backpack bloated with books and papers. It felt good to see someone from school.

"How's it going?" John asked.

"Not bad. What's up with you?"

"Not much, man. Hey, am I bringing you your tests, too?"

"No," Tony said. "I have to go to the office to take tests. Like after school or something, when everyone else is gone."

"Good idea," John said as he knelt and shuffled through his backpack. "Victor is pissed, man. If you were at school, he'd kill you."

"Really? I mean…does everybody know?"

John laughed a high-pitched, nervous laugh. "Are you kidding? Of *course* everybody knows! It's like headline news. At least it was last week. They already painted over the wall, and Reynolds's car is in the shop, get-

ting a new paint job." He grabbed a handful of papers and handed them to Tony.

"Yeah, well I hope he's getting a cheap one. It's gonna take me the whole summer to pay for it."

"Yeah, well, at least they didn't expel you."

"Stop," Tony said. "You sound like my mother."

They didn't talk for a few moments, then Tony asked, "So what did everyone think?"

"About what?"

"About what I did, man. About, you know...my work."

"Your *work*? Who are you, Picasso?"

"You know what I'm saying, dickhead."

John laughed. Then he said, "I don't know. Everyone was like, 'Tony who? You mean the Chinese kid did that?' They were bugged out. But it was cool, you know. People laughing at Victor, making fun of him. But that's what I'm saying—he's *really* pissed, man. I mean, he *really* wants to kill you."

"Thanks. You mentioned that already."

John gave him a goofy smile and shrug. "Alright, I'll see you tomorrow."

For the next four weeks, John brought him his assignments. Tony read and did his schoolwork at the restaurant and went to Mr. Johnson's office after school to take his tests. Mr. Johnson was never there, so Tony would sit next to the secretary, who normally read a magazine or chatted on the phone. He wondered if she was getting paid overtime for babysitting him.

On his walks to and from school, he kept an eye out for Victor, wondered if Victor knew that special arrangements had been made and that there was a chance he might be able to get his hands on Tony by hiding or lurking in the streets. So the streets became like the hallways of the school as he walked fast, eyes peeled, in the coming summer heat. In the past, he

felt he had done nothing to deserve the abuse he got from Victor, but now there was plenty of reason, and everyone knew it.

As the days went by, his parents spoke to him only when necessary, when they wanted him to do something at the restaurant or had a question about his schoolwork. They weren't mean; they weren't nice. They simply were, and he thought it strange how his parents did not look at him or trade small talk or little comments with him anymore, as if that part of their relationship had suddenly disappeared. Maybe they were still so angry with him that they didn't know what to say or how to act. He could see it in their faces, feel the tension that surrounded them like a cold hard wall.

The days went on, and Tony calculated how much of his debt was being repaid. Each day, he worked eleven hours, at three dollars and fifty cents an hour (off the books), so that was almost forty bucks a day. A cheap paint job would have cost The Mole maybe five hundred bucks, but Tony knew he would get the most expensive paint job he could for his big white whale of a car (and he definitely needed the whole thing redone, as Tony had bombed it thoroughly from end to end), so it was probably closer to two thousand. Not to mention fixing the school wall, which was probably another thousand dollars, tops. But how were his parents calculating? Were they keeping track of hours and days? They certainly didn't do that for themselves, and Tony did not sign a book and record his hours the way the cook and the other kitchen guys did every day and night. So how would he know when his debt had been paid? He wanted to ask his parents, but that wall of silence was thick, impenetrable. He thought he would bring it up in a few weeks, when he felt he was closer to repaying it all.

At night when they went home to eat, it was more of the same. His parents did not speak to him, and he began to feel like an unwanted border in the apartment. After dinner, he did his sit-ups and push-ups, but did not know if he felt skinnier, if he was losing any weight. He looked forward to chatting with John when he came to bring his school assignments, even looked forward to doing his schoolwork and the short walks to school to

take tests next to Mr. Johnson's overly perfumed old secretary; to remind himself that he was still a part of the high school, that he was a student and not a full-time restaurant worker, and that someday he would go back to school and life might be normal again.

He bought a small notebook from the hardware store that he hid under his mattress, but it wasn't the same now: the pages were too small, plus they were lined, and when he drew, he felt awkward, misguided, weak. The impulse that once coursed through his blood and into his hands and through the pencil was now gone. He had no urge to sneak up to the roof and dig out his spray cans, and his brain did not percolate and bubble with visions the way it used to. It was as if for one day he had lived the dream of being TERA 180 and now everyone knew who and what it was, and so that part of him was dead.

John brought Tony his last set of assignments as he prepared to take his final exams. The tests did not worry him. Instead, he added up what he had made working at the restaurant by now. At fifty-five hours a week for four weeks, he had made seven hundred and seventy dollars. It felt like it was a lot of money, but he needed to find out exactly how much he owed. He had a feeling that his mother knew, since she was probably the one coordinating with the school.

He went to Mr. Johnson's office two days before the last day of school to take his exams. He could feel, even in the empty hallways, a lightness in the air, that feeling of release when each school year came to an end and every kid could look forward to sleeping late and not doing homework, that invaluable summer escape. Sitting with the secretary, he took his exams and knew he had aced them. He walked home feeling good about himself, about his prospects. Maybe his mother had been right: he was lucky. Being expelled, or even left back a grade, would have been unthinkable. Now, he would trudge his way through the summer, pay back whatever it was he owed, and move on. He could still draw, still paint once the controversy

had blown over and he had earned back some trust with his parents and teachers. What he would do about Victor he had no idea.

He wanted to change into his work pants before going to the restaurant, so he went back to the apartment first. He found his father on the phone in the kitchen, speaking in Chinese in a loud voice.

"Okay," his father said. "We'll talk in a few days. Okay, take care, good-bye." He hung up. Then he looked at Tony and pointed at the table for him to sit down.

"That was your uncle in Shanghai," his father said. "Your mother's little brother. You remember him? He came to visit a few years ago."

"Oh. Right."

His father paused, sighed, rubbed his hand over his face. His eyes were red. He looked as if he had not slept in many days.

His father said, "You're going to stay with him next week. In Shanghai. I already bought your ticket. He owns a restaurant, much bigger than ours, and he needs the help. I told him that you were a good worker."

His father did not look at him as he spoke, as if he were reciting the speech to an empty room. Tony could not believe what he was hearing. Again, that wet-clay feeling, that empty, hollow burn in his stomach and brain.

"Shanghai? For how long?"

"The summer."

"The *whole* summer?"

"Don't raise your voice to me, Tony."

The air seemed to freeze between them, and so neither spoke for several moments. They listened to the screech of the subway, the sound of little kids laughing far away. Then Tony said, "I don't want to go to Shanghai. I'm not going."

"It's not up to you," his father said.

"You just want to get rid of me. You want to punish me even more!"

"No," his father said. "We're not trying to punish you." His father

stood and paced the living room with his hands dug deep in his pockets. He slouched as he walked, muttered to himself. He said, "It's hard to explain, Tony. But this is the best thing for you. For all of us."

CHAPTER 6

Later that night, his mother explained that he would be paid for working in his uncle's restaurant, but his wages would continue to be collected until his debt had been paid back. His uncle would also give him a small allowance, and provide anything else he might need—food, shelter, transportation. She tried to impress upon him what a great opportunity this was, how lucky he was to be able to visit where his family came from.

"Shanghai is wonderful," his mother said. "It's changed so much since we've left. Much bigger, newer, more beautiful. You'll have fun." He could tell from her tone that even she did not believe this, wanted to ask how much fun he was supposed to have working for a man he did not know in a strange city halfway around the world.

During the next week, his mother bought him new shorts, a few new shirts, a new pair of sneakers. He did not thank her, did not speak to his parents, even though they were more open and chatty toward him now. The day before he was supposed to leave, he asked his mother, "Why are you trying to get rid of me?" He was angry and sad, had felt a hot burning pit in his stomach all week. He saw the look change in his mother's face, the hurt and confusion. Her eyes grew watery. She grabbed a tissue and blew her nose.

"We're not getting rid of you," she said. She took a deep breath, a moment to collect her thoughts. Then she said, "Parents always think they are doing the right thing for their children. Trying to protect them, afraid for them. But you're right—you work hard, you are a good son. And we don't give you enough credit. We should have let go sooner, given you more freedom. So it's time for you to get away from us, from here, just for a little while. Your uncle is a good man—a hard worker, lots of energy. And I want you to see where your father and I grew up, where we came from.

"We figured you could spend the summer here, hating us, being angry. Or you could go over there and live and work and see what happens. I think it will be good for you, Tony. We would never do anything to hurt you. I know we don't show it enough, but we love you. We've been treating you like a little boy for too long now. We want you to grow up to be a man."

That night, they sat him down at the kitchen table to go over his itinerary once more.

"Your uncle will meet you at the airport," his mother said. "Be courteous, respectful. Remember, you're a guest in his house. Don't talk too much. Don't ask too many questions. If he tells you to do something, you do it. We've talked to him. He has our authority. We're not going to call you every day to check in on you. We want you to learn to do things on your own."

"Why do I have to go all the way to Shanghai to learn to do things on my own?"

His parents looked at each other. Both shook their heads. His mother said, "This is exactly what we're talking about. Don't be wise. It's okay to be a bigmouth in America, but Chinese kids don't act like that. Remember, the more you talk, the less it seems you know. Don't lose face over there."

His father said, "Watch out for pickpockets, all the pushing and shoving in crowds. They'll know you're from America just by looking at you."

Out of everything his parents had been prattling on about, Tony thought that this made the most sense.

His mother got up and went to her bedroom, then came back to the table with a package wrapped in shiny silver paper, tied up with red ribbon and a red bow. A gift for his uncle, he thought, something he was meant to lug overseas, a thank-you for taking in his wayward nephew.

"Open it," his mother said.

He looked at her, then tore through the ribbon and bow and paper. His mother frowned. She'd had that sad semi-frowning look on her face all week. When he saw the box, he realized it wasn't for his uncle at all.

"A Gameboy," he said. His mother was smiling now. His father was reaching across the table to examine the box more closely; there were two game cartridges as well. He had been coveting a Gameboy since it had come out a few years ago, would pester his parents for one every year at Christmas time and for his birthday. "Too expensive," his father would say. "Maybe next year," his mother would say.

"For the plane," his mother said. Her eyes were getting watery again.

He had never gotten such an expensive gift in his life. Maybe his parents did not hate him after all. Or maybe they were buckling under the guilt they were feeling for sending him away.

"Thank you," he said. "I mean…wow. I love it."

"You're going to need it," his father said. He stood and walked over to Tony and gave him a firm slap on the back. "It's a twenty-hour trip to Shanghai."

The next morning they took a taxi to the airport, where his mother cried and his father stood quietly behind her, rubbing her arms with both his hands.

"Call us whenever you want," she said.

Tony said, "I'll be fine," even though he was not sure.

His mother said, "I wish your grandparents were alive. Make sure your

uncle takes you to pay respects." She cried more, and Tony gave his mother a long firm hug. Later, as he waited on a line for passengers only, he looked back at his mother whose face was pink and crumpled, her head leaning on his father's shoulder. Even his father was wiping his eyes with the back of his hand. They were both waving. Tony felt a lump growing in his throat, his eyes itchy and wet. He gave them a quick wave. The man checked his passport and nodded and Tony pressed on toward the gate.

He tried not to think about his parents or the plane ride. He had never left home before, had never been any farther than Coney Island in Brooklyn, that one time a few years ago when his parents closed the restaurant on the Fourth of July so they could go to Astroland and ride the Cyclone. That had been a good day, even though it had taken his mother a couple of hours to finally relax and enjoy herself. His father had been into it right away—buying everyone cotton candy, ice cream, and soda. "Are you trying to get sick?" his mother had asked, but his father laughed it off and bought them corn dogs on a stick. They played games that tested their strength and speed and luck. Tony's father won a stuffed animal that his mother said was ugly even as she held it close to her chest. His father's favorite had been the Cyclone, which his mother refused to go on more than once. So she waited for Tony and his dad as they roller-coastered two, three, four more times under the hot sun, feeling more and more sick after each ride, compounded by the sticky, happy, stomach-tumbling subway ride back to the Bronx.

As he waited by the gate waiting to board the plane, Tony dug around for more happy memories, but it was that trip to Coney Island that stuck out most in his mind.

Passengers began lining up to board the plane, and Tony realized he was really about to leave home and his parents and the Bronx, and would not be returning until the end of August. He had no idea what to expect. In his own silent protest he had done no research on Shanghai or China. He looked Chinese, could speak Chinese—what more did he need to know?

He had not asked his parents to see pictures or give him background information. He was going in blind, and now he regretted it. Twenty hours on a plane? He wondered if he could possibly play video games for twenty hours straight. He thought, I might as well be going to the moon.

From New York to Hong Kong, the stewardesses gave him as many sodas as he wanted, always with a smile. The food was not bad—chicken and rice, vegetables, beef chunks, pasta, even cheesecake for dessert. He had witnessed the takeoff and landing, felt the rush and torque of the engines, the drop of his stomach and the tilt and magic rise into the sky. He played his Gameboy until his thumbs ached and his eyes burned.

During the two-hour layover in Hong Kong, he saw policemen in black berets walking through the airport with machine guns slung over their shoulders. He reached into his backpack, then realized his sketchbook was gone. His first impulse to sketch in weeks, and he had no paper or pencils. Wouldn't happen to a real artist, he thought.

Now, coming into Shanghai, he watched again as they descended through blue sky and white clouds. The sun was shining, and through the mist and haze he saw the city coming closer, growing, spreading beneath him. He saw spirals of highways and grids of houses and buildings, towers in the distance. He saw the two rivers that outlined the city, blue lines of snaking water, felt like he was watching an arrangement of models or toys. As they came closer to land and objects came to scale, he felt that pressure in his head, the flip of his stomach, ringing in his ears. The plane seemed to bounce as they landed, and then they were comfortably taxiing toward the terminal. People were up and retrieving their overhead luggage even before the captain had given them permission.

As they filed off the plane and into the terminal, Tony followed the stream of people. He had a picture of his uncle that his mother had given him, a phone number scribbled on the back. All the signs in the terminal were in Chinese, which he could not read, so he marched and followed the

stick figures on the signs and figured worse come to worst, he would ask someone for directions. All around him everyone was Chinese, black hair, dark eyes, loudspeaker announcements blaring overhead in Mandarin, which he understood, though he was accustomed to speaking Shanghainese. As if he had entered some kind of alternate universe, there was not one black or Hispanic person among the milling crowd, only a few white people sprinkled in here and there. Stranger in a strange land, he thought. Was it from a song, or from a book he had read? Either way, it was true.

As he approached the baggage claim area, he looked for his flight number on the signs above, then watched the bags and suitcases being spit up onto the conveyor belt, twisting through the crowd as people jumped forward to grab their belongings. Then he felt a hand on his back, remembered what his father had said about pickpockets, spun and grabbed the hand and looked up, recognized his uncle's face from the picture.

"Wow," his uncle said. "Your mother said you were chubby, but...uh, I thought you would be taller." He grabbed Tony's hand and shook it, then pulled him into a hug. "Alright, let's get your stuff."

He was about his father's height, five-foot-seven, wrinkles all around his eyes and crisscrossing his forehead, had short, choppy hair, and smelled of cigarettes. His very white skin made his yellow teeth even more noticeable. Tony saw his bag coming around and pointed, and his uncle stretched forward and grabbed it with one hand, his watch sparkling in a flash of gold light. Then he grabbed Tony by his wrist like a child and guided him through the crowd.

In the parking lot, the heat was like a quilt of steam and flame. With each step, he felt drops of sweat beading on his forehead and dripping down his neck and back.

"You okay?" his uncle asked. "You're all out of breath."

"I'm fine," Tony said.

"You'd think we were running a marathon!" His uncle smiled, but Tony did not smile back.

The car was small and black, shiny, new. They threw his suitcase in the trunk and plopped themselves inside. His uncle rolled down the windows and Tony gave him an incredulous look. "Okay, okay," his uncle said. "I'll turn on the air conditioner. I forgot how you Americans can't stand the heat. We're going to have to work on that."

Once they had left the parking lot, his uncle cracked the window and lit a cigarette. "You don't smoke, do you? Of course not, your mother would kill you. Don't tell her I smoke so much, she'll give both of us grief. And don't let me catch you smoking any of mine, either. Okay, I'll let you smoke one, if you're curious. But that's it. These things will kill you."

"I know," Tony said. The smoke was bothering him, so he cracked his window to get a cross breeze inside the car. It felt strange being driven; he was used to taking buses and subways and walking everywhere he went. He felt the soft leather seats and admired the interior, the dashboard and windows and console all polished to a shine. He was again admiring the sparkle of his uncle's gold watch when his uncle looked back at him and smiled.

"Rolex," his uncle said. "When you own your own restaurant, you can get one for yourself."

Tony nodded, reached for the radio, and his uncle turned it on for him: a Chinese pop song, a woman singing in Mandarin with a high-pitched squeaky voice.

"You like Chinese music?" his uncle asked.

"Never heard it before."

"Your parents don't play Chinese music at home?"

"Not really."

"Not in the restaurant, either?"

"Not in our restaurant," Tony said.

"Well, what kind of music do you like?" his uncle asked.

He paused, was having a hard time with his uncle's accent, needed an extra second to make out each sentence. In his head, he tried to translate what he wanted to say from English to Chinese.

"I like rap music," Tony said, saying "rap" in English.

"'Rap'? That loud, crazy garbage? Every song sounds like a street fight. Kids listen to it here in Shanghai. They listen to all kinds of American music. Madonna, Michael Jackson. You'll feel right at home."

As they turned off the highway, his uncle said, "We're going to my apartment. It's in one of the new apartment complexes." His uncle finished his cigarette, then flicked the stub out the window. "I cleared out the office for you, so you should be fine. There's a small bed in there. Tomorrow, we go to the restaurant. Your mother told you what the deal is, right?"

Tony nodded and said, "I think so."

"Don't think—let's be clear. You stay with me, you work with me, you do what I say. Your mother told me you're used to working in the restaurant, but this is nothing like your parents' little shop. My place is big, it's fast, it's busy, and I can't afford any slackers. From the looks of it, you're used to doing more relaxing than working. I'll tell you right now, I won't put up with it."

He did not expect a lecture right off the plane, but Tony was so tired that he just nodded as his uncle's words droned on.

"Another thing," his uncle said. "I'm in charge of your diet."

"What?"

"You heard me—I don't want you eating crap all the time. Small meals—rice, chicken, vegetables. No junk food, no restaurant food. Don't ever go in the kitchen. The chef will kill you, then he'll come after me. He doesn't like strangers in the kitchen. But we are going to watch what you eat, get you exercising, moving around instead of sitting on your ass. You've got to get in shape, my chubby little nephew. I'm going to make sure of that."

Again his uncle smiled, but Tony just stared at him. Then he looked out the window and realized they were in the city now. It seemed as if a horde of bicycles and motorcycles had been unleashed all around them, ridden by men and women, young and old. He saw a man in a suit and tie and sun-

glasses, smoking a cigarette, and a woman in a long skirt and high-heeled shoes steering with one hand while holding her hat on top of her head with the other. No helmets, everyone mixed into the traffic that moved in sporadic spurts. He heard horns blaring, watched as a couple on a moped scooted in and out between cars, trying to get through. At the red light, pedestrians streamed into the road like runners at the beginning of a marathon, one teeming mass clogging the streets. At an intersection, he saw another wall of bikes and motorcycles waiting to roar across. Then his uncle's car jumped forward and they spun around a turn and through a red light, nearly hitting two people crossing the intersection.

"Have to be quick," his uncle said, "or else you'll be stuck for days," and Tony wondered how people did not get splattered in this chaos.

The road was clearer now. Along the side of the street, Tony watched a man with no shirt pulling a wood cart piled high with lumber, could see the shape of the man's ribs through his dark skin, could not tell his age from the look of his eyes and face. The man reminded him of the can man back home who wandered the streets, always pushing a shopping cart filled with cans and bottles and other miscellany—a radio, extra shoes, books, and magazines. Tony looked up and saw all the buildings packed in next to one another, high and low, façades shielded by billboards and banners and big neon signs. He saw packs and clusters of people walking, realized that almost everyone was wearing pants in the sweltering heat, sauntering around as if it were a mild spring day.

They came to another patch of congestion. His uncle put the car in neutral, then rolled down his window to light another cigarette. Tony could hear the sound of a pile driver breaking up the street somewhere in the distance, the beep of construction trucks, a man's loud voice giving orders, the first sounds of Shanghai that he actually found familiar. Down the road there were less cars, a one-way street lined with trees. All the buildings were the same washed-stone color. They turned into a parking lot, and his uncle pointed up at the tower next to them.

"We're here," his uncle said. Back into the heat, Tony heaved his suit-case out of the trunk and instantly he was sweating again. He looked up. The building was tall, at least thirty floors, a dreary gray façade that reminded him of some of the bigger tenements back home in the Bronx, over twelve thousand miles away.

As they walked up to the building Tony asked, "What kind of car is that? Mercedes?"

"BMW. When you own your own restaurant, you can get yourself one of these, too."

CHAPTER 7

His uncle told him that he had to go back to the restaurant. "The jet lag is going to hit you soon. Try to stay up and fight it. But if you have to, take a quick nap. Don't sleep too much. You have a full day of work ahead of you tomorrow."

Tony dragged his suitcase into his new room, a long rectangle with a bed and desk against the wall. He thought he should unpack, but was so tired he flopped down on the bed to rest his eyes and was soon asleep. When he woke, his uncle was not there. On the kitchen counter he found a plate of chicken and broccoli and a bowl of white rice waiting for him. Outside the living room window he could see the glowing jagged Shanghai skyline speckled with colored light.

He walked around the apartment—a living room, a small bathroom, an open kitchen with an island counter and a few stools. The appliances were shiny stainless steel; everything in the apartment looked so clean—the floors, walls, even the furniture looked new—which was very different from back home, where every object and square inch of space looked dingy and used. He wondered how long his uncle had been living in this place, how much it cost, how rich his uncle really was.

As he ate he watched television, a game show with children in brightly colored uniforms competing in some kind of relay race. He flipped to the news, had a very hard time following the Chinese broadcasters who spoke Mandarin so quickly and with such precision and authority. If they had been speaking Shanghainese he would have been okay, but everything on television was in Mandarin. He was having that out-of-body feeling again, that floating sensation of observing from a place outside his brain. He watched a soap opera for a few minutes, then a show on cars, then turned off the television after getting through half of a dubbed episode of *L.A. Law*.

The food tasted good, he figured probably something his uncle had brought home from the restaurant the night before. Was the restaurant's menu this simple? He expected far more elaborate dishes. Dehydrated from the plane, he drank glass after glass of water. Then he felt sleepy again and went back to his room, where he closed his eyes and wondered what his parents were doing back in New York, if they missed him and regretted sending him away. He heard his uncle come home, kept his eyes closed and feigned sleep as his uncle opened the door to check in on him. His uncle mumbled something under his breath, then closed the door, and Tony tried to will himself back to sleep, thinking about Maria, wishing he could fast-forward through the summer so he could go back to New York (back to school, no less) and tell her what it had been like to be banished to another country on the opposite side of the world.

In the morning, his uncle pulled up the blinds and shook him awake.

"Put on shorts and sneakers," he said.

Tony opened his eyes, and through the window he could see the sun rising orange and red in the distance. He hadn't even unpacked yet, had to dig through his suitcase to get dressed. Then he followed his uncle down to the courtyard that connected all the buildings in the complex. There were big plots of green grass separated by concrete walkways, wood benches

and trees. On a patch of grass beneath the shade of a tree was a group of mostly old men and women with their hands lifted as if in fighting position, gliding up and down and side to side, as they simultaneously balanced and shifted from one toe-pointed position to the next, swaying in slow motion like robots in a frozen dance.

"What are they doing?" Tony asked.

"Tai-chi. It's like meditation and exercise."

They walked past the old people to a small squared-off area that looked like a children's playground with balance beams and sets of metal bars. But again it was all adults and older people, kicking their legs and swinging their arms, shaking, bending, twisting at the waist. A few people off to the side were doing tai-chi by themselves. The sun peeked over the trees that surrounded them, a hot yellow glow. Tony was already sweating, felt the mugginess and humidity like an extra layer of skin.

"Alright, just do what I do," his uncle said.

"What time is it?" Tony asked.

"It's six in the morning. Now concentrate."

His uncle raised his arms over his head, then shook out his hands, then did a series of bends and lifts, stretches and kicks. Tony followed along as best he could. Then his uncle told him to lie down on the grass for sit-ups, and Tony squeezed through fifteen, felt his stomach grumbling, a dull ache pulsing in his temples. He had never gotten up this early to be this active. It was unnatural, he thought. Even as he lay there, staring up into the sky, his uncle hovered over him and said, "That's all you can do? C'mon!" He grabbed Tony's hands and lifted him through ten more sit-ups, up and down, up and down. His back started to hurt, but before he could say anything, his uncle made him flip over for push-ups.

They finished by jogging around the complex four times, by which point Tony's shirt was soaked front and back, his hair dripping with sweat. Panting, he leaned over with his hands on his knees, could feel the sting in his lungs, heat like a necklace of red coals draped around his neck.

"Unbelievable," his uncle said. "Your father told me you do exercises in your room every night. Is that all you've got?" Tony looked up and saw that his uncle was smoking a cigarette, barely sweating. As he blew out a cloud of smoke, he waved to a few neighbors passing by. "My fat nephew from America," his uncle called out, pointing down at Tony. "See what eating all that American fast food will get you? Stay away from Kentucky Fried Chicken!" His uncle's smile spread even wider. "Come by the restaurant—I'll save you a table!" Then he looked down at Tony and said, "Get cleaned up. We have to go to work."

An hour later, Tony followed his uncle down the avenue. He thought they would be driving to the restaurant, but his uncle said, "No, impossible to get parking. We're taking the bus."

The bus, Tony thought. Finally, something I can handle.

They walked by a street lined with people selling from carts and baskets and sacks of vegetables and fruit on the side of the road. It was only seven-thirty, but on the main street cars and motorcycles and bicycles were already swarming. Did this place ever rest? At the bus stop they waited with more than a dozen people, reading magazines and books and newspapers, or listening to headphones. When he saw the bus coming, his uncle grabbed him by the wrist and began pulling him toward the front of the pack, and like a crowd of zombies everyone began to lurch forward. Tony could see the bus was almost full, and as the doors opened he could feel hands and elbows and knees in his back and ribs, trying to shove him aside. Tony dipped his shoulder and followed the force of his uncle pulling, and wedged his way through.

"What the hell was that?" He said it in English, saw a few people look at him and then look away. The bus started to move, and Tony tried to look outside to see if anyone had not made it on, maybe chasing the bus like a scene from a movie. But he was packed in between two young men and an older man whose armpit was in his face. There was no air condi-

tioning, the air dead and thick around him. He grabbed onto his uncle's arm for balance; his uncle didn't seem to notice, as the bus screeched and bumped its way along. His uncle leaned down and said, "You know, they are building a subway line here in Shanghai. Like the ones you have in New York, except it will be cleaner, and faster. I've seen the trains you ride over there. So dirty, disgusting. No one takes care of them. It won't be like that here."

"They're not that bad," Tony said.

His uncle looked down at him and smirked. At each stop even more people got on, until it seemed like they could not possibly fit another body; and yet they did, crushed in like sardines in a can. No one said a word or seemed bothered by the congestion, but Tony was finding it hard to breathe. Was he claustrophobic? He had been on tightly crammed buses and subways before, but never anything like this.

When they got off twenty minutes later, the first thing his uncle did was light a cigarette. He looked as comfortable and relaxed as a weed in a field, while Tony was so hot and sweaty he thought he probably needed to buy a new shirt. They crossed the street, Tony trailing behind his uncle as they dodged an oncoming wave of cabs and motorcycles, then stepped through the endless stream of riders and wheels in the bicycle lane. Many of the storefronts were already open, as girls in white uniforms stood in front of restaurants serving buns out of stacked, steaming baskets to people carrying suitcases or walking with their children. In the distance, he could hear the beep and shriek and thunder of a crane, the hammering of a pile driver.

His uncle said, "This is Nanjing Road, the most famous shopping road in all of China. Anything you want, you can buy it here—food, clothes, jewelry, electronics, antiques, stupid trinkets, you name it. American name brands, too. Big designer stores. In a few years they are going to close down the east part of the road, make it a pedestrian walkway only. Which is smart, you know. You have to think ahead to keep up with the times. That's why everywhere the city is building—new towers, skyscrapers, big

hotels, the new airport across the river. All of it will bring in more business, more tourists. If your parents were smart, they'd move back and get in on the boom before it's too late."

"I don't know," Tony said. "I think we're okay over there."

"I know, I know, your parents are settled. They made their choice. But I'm telling you, Shanghai is going to be the biggest and richest city in the world some day. Bigger than Hong Kong or Beijing—even bigger than New York." There was a far-off look in his uncle's eyes, then he snapped back and said, "Anyway, if you ever get lost, just get in a cab and tell them to take you to Nanjing Road. You wander long enough, you'll find the restaurant."

As his uncle said this, they turned into a door beneath a big red-and-gold sign, walked past a giant tank filled with big, bubbly goldfish built into the wall. "For good luck," his uncle said. "Keeps the bad spirits away." They were welcomed by a chorus of greetings: "Good morning, Boss...Boss, how are you?" His uncle did not reply, just nodded and waved as people were setting tables, polishing silverware and plates, folding napkins, cleaning windows, vacuuming. The dining room was filled with dozens of tables, big and small. A chandelier hung from the center of the ceiling. Dark red carpet covered the floor, gold lace curtains and drapes adorned the windows. In the back of the restaurant were two sets of swinging doors next to each other.

"Always go to the left," his uncle explained. "That's the pickup, prep, and cleaning area. The right is the kitchen. See that sign up there? It says, 'Never go in the kitchen.'"

Tony nodded, half-listening, as he stared at a wall of paintings and scrolls of Chinese calligraphy, all mounted and framed, in the back of the dining room. He began walking toward the paintings, but his uncle grabbed him by the arm and handed him a white shirt and apron.

"So what am I doing?"

"A little bit of everything," his uncle said.

First, he helped make dumplings with four women whose faces he could not see behind the paper masks they wore, covering their noses and mouths. His uncle said, "This is my nephew. Show him what you're doing. Don't be afraid to correct his mistakes." They gave him a pair of white rubber gloves, a hairnet, and a mask. Tony did not wear the hairnet, and no one said anything. He watched the women take pinches from a big mound of chopped meat and place each pinch carefully in the center of a thin square of peeled dough. Then they lightly wet the edges of the peel and folded it up. He did as they did, was not sure if he was doing a fine job or if his dumpling-making partners simply didn't care. But it made more sense to him now why the dumplings they served back home were bought frozen. With only him and his parents and the few guys they hired, who had this kind of time?

Two hours later, his uncle found him and said, "You're going to be bussing tables, okay? Wait here…Min! Hey, Min! Come over here."

A young woman walked over. She was a couple inches taller than Tony, had red lips and long black hair tied back in a ponytail. Her eyes were big and dark and shining. She smiled at Tony. His uncle said, "Why aren't you dressed yet? The lunch rush starts soon."

"I'll be dressed in two minutes," the girl said. "Don't worry so much, okay?"

"Fine, fine," his uncle said. "Anyway, this is my nephew from America. He'll be working here for the summer. Show him how to bus tables. Let him work in your section. Tony, this is Min. She's a joker, so watch out for her." His uncle ran off and left the two of them standing.

"Tony from America, eh? You came all the way over here to bus tables?"

"Looks that way," Tony said. He thought she was eighteen or nineteen, no older than twenty. He liked the way she said his American name, how natural it sounded in her voice. He could not look her in the face, so he kept his eyes down.

"Well, c'mon. I'll show you what's what." She walked him through the section of tables he would cover, showed him where to bring the dirty

plates and glasses, where to throw used napkins and tablecloths, where to get new place settings.

"Make sure you wipe down the dolly whenever you clear a table. Your uncle goes crazy over that kind of thing."

"Seems like he goes crazy over everything."

She looked at him and laughed. "Tony the wise guy from America?"

Tony shrugged and tried not to smile. As he followed her around the restaurant, he could smell her perfume trailing behind her.

Thirty minutes into the lunch rush almost every table was full, the noise and clatter of chopsticks clinking and clicking against dishes, people laughing, calling out for more water, more tea. Tony fell into the rhythm, zigzagging in between tables and back and forth through the left-side doors. Everything here was so much bigger and faster and more frenetic than the tiny operation his parents ran back home. He dashed around his section, filling his rubber bin with empty plates and bowls and glasses, all the while keeping one eye on Min. Like the other waitresses she wore a long red dress buttoned high up on her neck, slit to mid-thigh on both sides, showing flashes of her white legs as she strode back and forth. He thought she looked older dressed like this, at least twenty-one or twenty-two. A few times she saw Tony and smiled back at him or gave him a wink.

When the lunch rush ended, his uncle closed the front doors and put up a sign that said they would reopen at five. Then the kitchen door swung open and a young man in a white jacket and big white hat brought out several plates of fish, shrimp, sliced pork, dumplings, cold noodles, rice. Most of the waiters and waitresses were changing and leaving for the day, but his uncle and the men coming out of the kitchen sat down and began to eat. Tony, starving, sat down as well, but his uncle said, "That's not for you." He pointed to one of the cooks, who ran back into the kitchen and came back with a plate of steamed vegetables and chicken and a bowl of thin pale soup. His uncle said to the cooks in a loud voice, "This is my nephew

from America. Don't feed him, no matter how much he begs. You see he's already a chubby little dumpling. I don't want him getting any fatter!"

The cooks all laughed. Tony kept his head down, shoveling rice into his mouth with his chopsticks. He looked at the plate that had been prepared for him, then at the food that was circling around the dolly in the middle of the table. He wanted to throw his steamed vegetables and sliced chicken across the room, tell everyone around him to go to hell. In English, so no one would understand him.

Instead, he took a bite of the chicken, a sip of soup.

"Boss," one of the older cooks said, "why don't you let him have a little?"

"No," his uncle said. "His parents told me to shape him up. I can't send him home looking like a pork bun!"

Again the cooks laughed. Tony ate faster.

Before he finished his last bite he saw Min standing by the front of the restaurant, waving for him to come outside. His uncle and the cooks were finishing up, so Tony stood and slipped out unnoticed. Min was still in her long red dress, and in her high heels, she was much taller than him. She lit a cigarette and tilted the open pack toward Tony, who shook his head.

"I shouldn't corrupt you. How old are you, thirteen? Fourteen?"

"Fifteen," Tony said. He felt a stab in his chest, his pride. He asked, "Aren't you going home?"

"I'm working the dinner shift, too. Need the money, you know."

"Sure," Tony said. Then he said, "Does everyone smoke in Shanghai?"

"Yes," she said. "Everyone. You don't smoke?"

"Not really," he said. "Once in a while."

Min laughed. They watched all the people streaming by, in and out of the cafés and bars and stores. It was late afternoon, and down the road many of the neon signs had been turned on, their glow lighting up the street and sky.

"How do you like Shanghai so far?"

"It's okay," he said. "Too much traffic."

"It's true. I need to get away, some place new. Maybe America, I'll come visit you. You have a big house?"

"An apartment," Tony said, "in New York City."

"An apartment in New York." Min smiled at him. "I like the sound of that."

His uncle came outside and found him. "What are you doing?" he asked Tony. "Get in there and help clean up! Min, I brought him here to work, not to keep you company."

"Relax, Boss! We were just talking about his big apartment in New York City. Besides, if he doesn't keep me company, who will? No one else in this place is ever nice to me!" She grinned and poked Tony's uncle in the shoulder. He grunted and waved his hands in the air and went back inside.

"Do you always talk to him like that?"

"Sure," she said. "I can do whatever I want. I'm the best waitress he has." Then she said, "So what do you do in New York? You go to school— what else?"

"I don't know. I work. And..." He tried to think of the correct Chinese translation for what he wanted to say. "I paint."

"You're a painter?"

"Sort of. I guess."

Min nodded and lit another cigarette, and Tony could smell the mix of her perfume with the smoke and the miasma of grease coating the air. He saw an old woman walk by, staring at him, then a man and a woman walked by doing the same. He wondered if it was him or Min they were staring at, figured it didn't make much of a difference.

"So, do you go to school?" Tony asked.

"School? No. I'm trying to be an actress, but it's not going so well. Too many pretty girls in Shanghai. You have to sleep with someone to get even the smallest role. Unfortunately, I still have some morals. Is it like that in America too?"

"I don't know. I guess."

His uncle poked his head back out. "Tony—inside, now."

Min said, "Nice talking to you, Tony from America."

The menu changed for dinner. Tony could not read it because it was all in Chinese, but as he patrolled his section of tables he heard Min announcing all the sensational dishes and grand concoctions as she served them—frog stew, fried chicken's feet, fish and eel in black bean sauce, steamed dragon rolls and dumplings, drunken chicken, four-happiness pork, lion's head meatballs, pearl balls and smelly tofu. It made him dizzy with hunger just looking at all the hot steaming plates.

He was scrambling about, faster now than he had during lunch. A few times Min had to tell him, "More water for table four," or "Clear off table six." He did as told, trying to remember which table was which, his back hurting, feet aching, legs getting soft beneath him.

"C'mon, Tony. Pick it up," Min said as she walked by.

He watched the waiters and waitresses bang through the left-side doors with empty trays and return with full ones. He filled people's water, refilled pots of tea, cleared the tables of little piles of chewed-up, spit-out skin and fish bones, tablecloths splattered with dark sauce and wine. His arms felt like jelly, his hands shaking and weak as he carried the full tub of dirty plates and bowls. His stomach was grinding again, wished he could go in back and scarf down just one steamed dragon roll, wished he could flop down in his old bed in the Bronx and sleep for a week. He saw his uncle, dressed now in a suit and tie, floating from table to table, a big smile on his face, trading jokes with his patrons, cajoling, laughing.

As he headed toward the back to unload his tub, he heard Min calling his name. She shouted for him to bring two new drinking glasses, a new place setting, and a towel. A towel? Where was he supposed to get a towel? He didn't know. He spun with his tub of dirty dishes still in hand and plowed through the swinging doors on the right, didn't see one of the cooks carrying a big steel pot, another cook behind him with a platter of

sizzling meat. Everything around him slowed down: he felt himself falling, the tub of dishes dropping from his hands; saw the one cook trying to balance and catch the pot, heard the pot hit the ground, the contents splattering on the cook's chest and legs and on the floor; the cook behind him running into his back, slipping, the platter of sizzling meat flying forward, over and on top of Tony and everywhere else. He could hear each sound— the pot clanking, soupy liquid splattering, the thud of his own body hitting the floor, the crash of dishes and slap of meat on the tile.

He had something in his eyes, hot, stinging, burning. He tried to stand but could not find his balance on the slippery floor. There was screaming, bellowing in a dialect that was not Shanghainese.

He felt a pair of hands slip under his arms and pull him up. He wiped his eyes with his shirt sleeve. The whole kitchen had come to a stop. The two cooks he had knocked down were wiping themselves off. Someone was handing them towels and rags. He heard his uncle's booming voice, "Okay, get this cleaned up! Back to work!"

His uncle was standing in the middle of it all, his suit and shirt shining clean in the midst of all the puddles and muck. The kitchen returned to action, and Tony's uncle pulled him by his wrist. The two cooks that he had knocked over and tripped had disappeared. Already, someone was pocking at his feet with a mop, telling him to move.

CHAPTER 8

Tony spent the rest of the night sitting in his uncle's office, watching the wall of monitors that surveyed the entire restaurant—the coolers, prep areas, kitchen, dining room, two on the front door and register. He pictured his uncle like the commander of a ship, observing his staff and crew. He figured there was video of the accident in the kitchen, and he thought back to what he had done to The Mole's car, how painfully unlucky he was for the two worst moments of his life to be caught on tape.

When his uncle came to get him it was past midnight. The restaurant was empty. They locked the front door and walked down Nanjing Road, Tony's eyes adjusting to the blast of neon, the assault of color like an amusement park or a carnival, the sparkling, twinkling, flashing. There were still people walking but not nearly as many as during the day. They hailed a cab; traffic was not as crazy or aggressive at this hour. His uncle didn't speak to him the entire ride home.

Back in the apartment, the first thing his uncle did was pick up the phone. "I'm calling your parents," he said. Did he have to rat him out this fast, right away? Couldn't they at least talk about it first? His uncle said, "Do me a favor, go in your room. Just for a minute."

Tony went to his room without argument and closed the door. It was sweltering inside. He tried to open the window but couldn't. He didn't want to go back outside and ask about the air conditioning. He would rather hide in the room and sweat than deal with the look on his uncle's face.

Just like home, he thought.

Through the door, he heard his uncle's voice getting loud. Had he called his parents in the restaurant? What day was it? His head was still spinning, thought he would get sick soon without sleep and nourishment. He lay down on the bed and waited.

A few minutes later, his uncle knocked on his door and told him to come outside. Tony expected the phone to be handed to him, but his uncle had already hung up.

"Did you talk to them?" Tony asked. He looked at his uncle, who crossed his arms and turned toward the living room. "They didn't want to talk to me?"

"Sit down," his uncle said. He pointed at one of the black leather chairs. They both sat, and his uncle sighed.

"Uncle, I'm sorry about the accident. But it was my first day, and I was so tired, and it was busy and I didn't see…"

"Tony, stop."

They sat in silence for several moments, his uncle not looking at him. There was a resemblance to his mother, around the eyes and forehead, the same crinkle of worry on the bridge of the nose, the loud, booming voice. Still, he did not know this man, didn't know what he would say or do next.

"I told your parents what happened. They wanted us to handle it. Just me and you."

"Uncle, I've been up all day, and I was still tired from the trip, and…"

"Stop making excuses." His uncle stood and walked over to the window. With his back turned to Tony, he began to speak. "In business, the only things that matter are results—what *happens*. And what happened was you

made a mistake and caused a big accident, and that is unacceptable. That soup could have been hot—you could have put the old guy in the hospital, do you know that?" His uncle kept pacing and waving his hands in the air. "The other cook burned his arms and threw out his back. Who knows if he's going to have to miss work. You're lucky you didn't get hurt yourself!"

He felt that sad heavy feeling in his stomach and chest again, weighed down as if he'd eaten a bag of cement. Go on, Tony thought, keep flapping your gums. He tried to think of the Chinese translation of this.

"Your parents told me about your situation back home," his uncle said. "I know you have some issues. That's why you're here. But I'm not going to take it easy on you. You have to train yourself to be smarter, sharper—it's the only way. How do you think I have this restaurant, this apartment? From hard work, planning, and determination—not by having my head in the clouds. You are only going to be with me for a few weeks, and you are going to shape up and focus. You might hate me, but like it or not, that's how it's going to be."

He saw that his uncle's face had smoothed, calmed. But Tony still felt hot and twisted inside. He said, "How much am I being paid?"

"What?"

"*Paid.* I'm not on vacation, you know."

"You fat little dumpling..."

"Didn't they tell you? I owe money. I need to keep track of my earnings."

"Tony, this isn't about money."

"It is to me."

His uncle looked away. "This is hopeless, just hopeless..."

Tony stood and headed back toward his room. He needed to sleep, knew his uncle would be standing over him, shouting, first thing in the morning. He needed rest if he was going to survive yet another day.

In the morning, the day felt hotter than the previous. They did the same exercises; the bus ride was the same; the restaurant was the same. Nothing

changed. He didn't expect it to. He resigned himself to the fact that this would be his life, doing the same things, the same way, every day, didn't matter if he was in New York or China or Timbuktu. It would be like this until he was old enough to leave home, take action, and make decisions for himself. After high school, he decided, he would leave, but then what? College? Work? Probably college, his grades would finally mean something. Where? In California, Los Angeles or San Francisco. How about Hawaii? He knew nothing about these places, had only seen and heard about them from television shows. But they were very far from New York— that much he did know—and that was all that was important.

He made dumplings in the morning and bussed tables again in the afternoon. Min was not there, and no one spoke to him, except his uncle who stayed in his ear, telling him to clear away this or refill that, pointing and barking. He stayed away from the doors on the right, felt people at the restaurant watching him even as they worked, imagined them whispering behind his back about how stupid and impossible the boss's fat nephew from America was. Just like school, like home—always eyes on him, always voices in the shadows. He didn't think he deserved this, wished there was a potion he could drink or a pill he could swallow, a way to transform this body, this life, all of it into something different and new.

After the lunch rush, the cooks sat down to eat, and Tony sat at a smaller table to the side. Separate meal, separate table—he did not want to deal with the snickers and glares of the staff. Instead his uncle came out and told Tony to take off his dirty apron. "Wash your face and comb your hair. I'm taking you to meet somebody."

They walked down Nanjing Road, through the mad rush of shoppers. Cars and motorcycles honked and beeped, as bicyclists streamed through traffic in a natural flow. A bus rumbled by, spewing black smoke from its rear. The sun beat down on them. He asked his uncle if they were going to take a bus or cab, and his uncle said, "No, it's not that far. Just deal with it. The exercise will do you good."

Soon, they turned off of Nanjing Road and onto a side street. There were fewer cars, the buildings shorter, smaller, no neon or big billboard signs, just old faded brick and tile roofs. People strolling casually, a few random bicyclists milling through the crowd, he saw baskets and crates of tomatoes, eggplant, ginger, garlic, asparagus, watermelon, beans, and realized they were in the middle of a market. There was woman beneath a big umbrella selling cold drinks out of a cart, reminding him of the flavored-ice lady back home on East Tremont Avenue; then an old woman in a booth selling tea leaves, next to an old man in an oil-streaked T-shirt working on a bicycle flipped upside down, a pile of random parts piled to his side. Last in line were several stacks of wire cages filled with clucking, wing-flapping, fully feathered live chickens. He remembered trips to Queens with his parents when they needed vegetables and spices that they could not find in the Bronx—the bustling markets, the Chinese faces and voices—but they were nothing like this. Tony could feel eyes on him as he and his uncle passed, remembered how his parents had told him that people would know he wasn't from Shanghai, that he was an American. From the looks on people's faces, he could not tell if this was a good or bad thing.

"Where are we going?" Tony asked.

"To visit a friend." His uncle was walking quickly, looking up at the buildings around him. He said, "All these old buildings are going to be torn down eventually. They'll build new complexes like mine, or commercial space. Either way, it's just a matter of time."

"Don't people live here?"

"Sure they do," his uncle said.

"Well, what about them?"

His uncle did not answer. Tony saw laundry hanging on lines across the street and from balconies. He did a double-take—were those raw, plucked chickens (or were they ducks?) hanging outside an apartment window? The smell from a narrow gutter along the side of the street reminded him of the subway platform in midsummer, the smell of hot garbage and piss,

steamy and rank. They passed a row of tables selling trinkets, souvenirs, jeans and shirts and belts. There was an older white couple haggling. "No, thirty yuan," the white man said, waving the few bills pinched in his hand. He had a Southern or Midwest accent. Tony was surprised by the sudden sight of white people in the crowd, but it felt good nonetheless to hear someone speaking English.

They left the market street and walked a bit farther, came onto a road that was cleaner, wider, lined with swaying green trees. They passed several big houses with fences and shiny cars in the driveways. None of the houses looked the same, some with terraces and fancy arches and smooth stone façades, others with plain gray walls and tiled roofs, wood shutters over the windows. None of them, Tony thought, looked particularly Chinese. Above the houses and blocking the sky, he could see the shadows of buildings and towers, the hulking mass of the city looming overhead.

They walked up to a plain three-story house and knocked on the front door, were met by a small older Chinese woman with short black hair and thick-rimmed glasses. She smiled and said, "Come in, come in. He's in the studio. I'll take you up." As they walked through the house, Tony noticed the décor: wood floors, a coffee table and couch, framed paintings, both big and small, on every wall. The house was not new, but everything looked so tidy, so clean; neat, organized, a calm sense of order. They took the stairs to the second floor, and the woman knocked on a door. A voice from behind the door said, "Come in," in Shanghainese.

"Thank you, Mrs. Zhu," his uncle said. He looked at Tony and Tony said, "Thank you." She smiled and nodded and went downstairs.

Inside the room, Tony breathed in the smell of dust and books, old paper and ink, a flavor in the air like faded smoke or spice. The blinds on the windows were half-drawn, making it cooler than it was downstairs. He saw a big table piled with books and other clutter, and behind the table was a little old man. He wore big glasses and a red sweater, had a long cloud-white beard and mustache, with a full head of hair to match. He was

leaning over the table, bracing himself with his left hand, a paintbrush in his right, eyes locked in concentration. With a steady wrist, the old man's right hand and arm moved together as the brush trailed down the paper. Then he stopped and looked up and gave them a smile.

"Master Zhu," his uncle said, "if you are busy we won't bother you."

"Nonsense," the old man said. "I've been looking forward to seeing you. I'm sorry I haven't been down to the restaurant lately. It's a lot of effort to go out for an evening these days."

"Of course, Master Zhu. You know a table is always waiting for you."

"Thank you," the old man said. "I will definitely be there in the fall, when crabs are back in season. Yours are the best in town." Using a cane, he took a few short steps and walked out in front of the table. He looked at Tony. "Is this your nephew?"

"It is." His uncle nudged him forward, and Tony reached out to shake the old man's hand. His grip was light and gentle, the skin of his hand smooth and dry like paper. "Say hello to Master Zhu."

"Hello, Master Zhu."

The old man smiled and laughed. He walked over to a black leather chair and sat, motioning for Tony and his uncle to do the same. There was a knock on the door—Mrs. Zhu had brought them a tray of tea. There was no air conditioning in the studio and yet it felt cool inside. Behind the table was a clothesline that stretched across the room with a handful of paintings, both big and small, hanging dry. To the side was a half-finished painting sitting atop an easel. Small green plants and miniature trees in red clay pots lined the windowsills. On the walls were framed paintings of multiple scenes and settings: mountains and rivers, plants, fruit, long scrolls of calligraphy. There were no portraits, no people. They each took a cup of tea, and Mrs. Zhu left.

His uncle said, "Master Zhu is a world-famous painter." Tony looked at the old man sitting in the big black chair, looking small and doll-like and elegant. "Those are all his paintings and calligraphy hanging in the restau-

rant. You are lucky to be meeting with someone as revered as Master Zhu."

"You're too kind," said Master Zhu. He turned to Tony and asked, "So you are from America?"

"New York," Tony said.

"Ah, New York—I like New York very much. A big, fast city, just like Shanghai. I was there some time ago. So much energy. And the museums—amazing. Have you been to the museums?"

"No," Tony said.

"You must go to the museums. They are the most impressive in the world. I saw paintings there with my own eyes that I had only heard about all my life. Truly a treasure. You must take advantage."

"I don't have much free time these days," Tony said.

Master Zhu, sipping his tea, did not seem to hear him, but Tony could feel his uncle's eyes boring into the side of his head.

"But Shanghai is a beautiful city, too," said Master Zhu. "A changing city. I'm sure you hear the construction going on everywhere you turn. I've been here almost all my life, just like your uncle. The buildings might change, but people don't change. That's what makes any place real—the people. Not the big buildings and pretty signs."

His beard and hair were so white, so fine, his smile cheerful, eyes bright. Tony wasn't sure what to make of him: he looked old, and sounded old, but he didn't *feel* old. Tony looked around at the paintings on the walls and hanging from the clothes wire behind the desk. What made him a master? What made these paintings so special? Maybe it was because he was so old, had been around so long. Was "greatness" just another word for longevity?

"Can I ask you a question, Master Zhu?"

"Of course."

"How old are you?"

Tony's uncle bobbled his teacup and spit out a dribble of tea. He wiped his mouth and said, "Tony, apologize to Master Zhu! Master Zhu,

I'm so sorry. He's...It's the American boy in him, no manners. Tony, apologize *now*."

But Master Zhu was laughing, pushing the points of his fingers together to make a steeple. "Young people," he said, "they don't know something, they ask. That's what they are supposed to do." He looked at Tony and said, "How old do you think I am?"

He could feel his uncle staring at him again, knew the question was burning through his uncle's guts. He knew if he said a number too low his uncle would think he was joking, being disrespectful. But if he said a number too high the result would be the same.

"I don't know," he said. "Seventy-five?"

Master Zhu laughed; even his uncle cracked a smile. Tony knew he was wrong, but didn't feel like he would get in trouble.

"Thank you for the compliment," Master Zhu said. "But unfortunately you are off by twenty-five years." He heard his uncle laughing, and Master Zhu was smiling wide.

"You're one hundred years old?"

"Yes," he said, nodding. Then he said, "Your uncle tells me you are interested in art and drawing. Is this true?"

Tony could feel his face get hot, a tight shrinking in his gut and chest. "Well, sort of, but not really."

"So you're not a painter?"

"Not with a brush and paper. Not like this."

"But you draw," said Master Zhu. "Let me see your sketchbook then."

"I...I don't have one."

Master Zhu stared at him, still half-smiling but not so amused anymore. "You don't have a sketchbook? An artist must have a sketchbook with him always. You must be sketching all the time. Or else you'll wind up forgetting all the fantastic visions that pop into your head. You can't depend on memory alone." He turned to Tony's uncle and said, "You should get the boy a sketchbook, don't you think?"

"Certainly, Master Zhu." Then his uncle said, "Enough, we've wasted enough of Master Zhu's time. I wanted you to meet him because he's a great painter—a master. You should feel honored that he would even answer your silly questions."

"Well, you can't leave before I give you a little tour of the studio," said Master Zhu. He turned to Tony and said, "I'm afraid it isn't much, but maybe it will pique your interest."

Master Zhu braced himself to stand, and Tony's uncle jumped up to help him. Tony saw how different his uncle was around Master Zhu, so respectful and doting. It was intriguing to watch his uncle ingratiate himself, while he was so bossy with everyone else.

Tony followed Master Zhu over to his painting table, which was filled with dozens of brushes, sheets of paper, other brushes of various sizes hanging from a stand. There was a big white bowl and smaller bowls filled with water, a dish of various splattered colors, what looked like a thick short black stick, the face of the table marked with drips and blots of paint. The painting he was working on was of a plant and what looked like crabs, from what Tony could make out. The strokes were rough, heavy, simple. The crabs were a bright red-orange, like a sunburst, and appeared to be as large as the plant. Tony leaned down to see the painting more closely, felt his hand brush against something, looked down, saw a small bowl tipped over, water spreading across the new painting, instantly smearing the plant and crabs into a blurry glob.

His uncle was shouting at him, "You idiot! Master Zhu, I'm so sorry...Tony, get over here! Don't touch anything."

Tony was still standing at the table, looking for a rag or towel, something to clean up the spill. But he was afraid to touch the painting, the table, didn't know if the painting was still salvageable.

"Get away from there," his uncle said. "Master Zhu, I'm so embarrassed. Next time you come to the restaurant, I'll take care of everything. I'm so sorry. I'm so..."

"It's fine, it's fine," said Master Zhu. "Nothing to worry about." Master Zhu folded up the paper, spill and all, and tossed it neatly into a pail. "I wasn't happy with it anyway."

His uncle went on. "He's just...I'm trying to help him while he's here, and I was hoping meeting you would show him some...I don't know, respect, or inspiration. Something. But I think he's just hopeless. Asking rude questions, and ruining your work space. We'll go now. Please accept my apologies, Master Zhu."

"No apologies are necessary."

"Come on," his uncle said to Tony. "Did you come to Shanghai on a search-and-destroy mission?"

Tony did not speak. He looked at Master Zhu, who did not show any signs of anger or annoyance. Calm, peaceful, his skin looked so smooth; Tony could not believe the man was one hundred years old. His uncle waved him forward and motioned toward Master Zhu. Tony shook his hand, bowed slightly. He was about the same height as Master Zhu and liked the fact that the old man looked him in the face, in the eyes.

"I'm sorry, Master Zhu," he said. The old man just nodded, and Tony and his uncle left.

On the street, they hailed a cab back to the restaurant.

"I can't take you anywhere," his uncle said. "Are you *trying* to embarrass me? I'm trying to *help* you, and you...you go out of your way to...Oh, forget it. Forget it!"

As they drove and bounced through the Shanghai traffic, his uncle next to him now silently smoldering, Tony felt the sharp dig in his thigh. He tried not to shift or squirm too much in his seat, did not want to bend or break the two brushes that he had grabbed from the painting table while his uncle had been apologizing so profusely on his behalf.

CHAPTER 9

That night he dreamed he was in a train yard. Like an acrobat, he was doing a full split between two train cars, bracing himself with his feet against the side of each car, his hands digging through his knapsack for his sketchbook and a can of paint. But all he had was a brush—a giant Chinese paintbrush that he pulled from his bag and waved like a sword. How am I going to paint with this? There were dogs below him, German shepherds, growling, barking, saliva dripping from sharp, glistening teeth. If he dropped down or fell, they would tear him to pieces. He spun the brush around and jabbed down with the wooden end to parry away the dogs, then jammed the brush into the ground and vaulted himself up and onto the roof of a train car. The dogs disappeared into a poof of dust and smoke. He stood with the brush in hand, now normal-size, staring at it like a talisman or wand.

The train beneath him began to roll out with a rumble, everything around him shaking.

"Tony, wake up."

He opened his eyes; it was his uncle glowering down over him. "What are these?" He was holding up the two brushes. "Get dressed now," his uncle said.

They did not do exercises or stop for breakfast. After heading into the restaurant to make sure things were on track, they went back to Master Zhu's house. His wife looked surprised to see them. "Let me see if he's available," she said. She invited them inside. As they waited by the door, his uncle said, "You apologize and that's it. Don't say another word or you'll be hauling garbage the rest of the summer. I don't care what your parents said—you making me lose face over and over again was not part of the arrangement."

It had gotten to the point, in just a few short days, where he was already tuning out his uncle. His voice did not seem so loud or threatening anymore. What was the worst he could do, hit him? Maybe, but he doubted it. If he could survive each day at school, he could certainly survive a few weeks of bussing tables and hauling garbage. His uncle's voice could easily be filtered into a harmless half-gibberish of commands and squalls.

Tony was more concerned about what he would say to Master Zhu. With everyone else he could look down silently and they would have to look at the top of his head. But not Master Zhu. He knew he would be forced to look into the old man's eyes, had an itchy gurgling feeling in his stomach, did not know why he cared. I'm so stupid, he thought. Why did I take those brushes? How was I even going to use them? He compared it to taking spray paint cans from the hardware store back home—easy, something to do just to prove he could do it. His mistake had been falling asleep and not hiding the brushes properly. He thought he deserved to be caught for being so careless.

Mrs. Zhu came back and said, "You can go up."

Upstairs, they were greeted at the studio door. Master Zhu was smiling. He was wearing the same red sweater. He waved them inside and motioned for them to sit, but his uncle said, "We won't be staying long, Master Zhu. I'm sorry to bother you. But I found these, and my nephew would like to say something to you." His uncle held the two brushes out in front of him, splaying his hand wide. So dramatic, Tony thought, trying to rub it in. Was he trying to embarrass him even more? Teach him a lesson? Rub salt

in the wound? Could he learn to hate his uncle as much as he hated school and Victor and The Mole and everyone else?

Master Zhu looked at the brushes. His smile faded. He nodded without speaking. "Come talk to me for a minute," Master Zhu said to his uncle.

They went into the studio and closed the door. Tony could hear them mumbling, wanted to press his ear against the door and listen but didn't want to risk being caught. He did not know how long he waited, the voices behind the door steady, no pauses or breaks. Then the door opened, and his uncle came back out.

"Come on, we're going." His uncle did not look happy, his brow furrowed, lips pursed. They walked back to the restaurant without speaking, dodging bicycles and motorcycles, getting beeped at by cars as they crossed the street. He struggled to keep up with his uncle, who moved so fluidly through the traffic and bodies. His uncle did not slow down or look back once.

In the restaurant, he helped prepare the dining room for the lunch rush. Min was there, looking beautiful in her long red dress and heels. She gave him a big smile when she saw him and said, "You're working my section. I guess your uncle knows I have a little crush on you, eh?"

Tony looked at her and blinked a few times.

"What's the matter? I'm just kidding with you."

"It's nothing," he said.

"Come have a smoke with me."

"I shouldn't. My uncle is mad at me."

"It's okay," she said. "He's always mad."

They worked through the lunch rush and when he did not see his uncle afterward, he went outside with Min. She offered him a smoke, but he shook his head.

"So what's wrong?" she asked. "I can help you handle your uncle, you know."

"Not this time," he said. He watched all the people passing by on Nanjing

Road, was struck again by all the Chinese, only Chinese, the faces and voices. He missed the sound of salsa and rap pulsing and floating in the air back home, the chorus of children's voices laughing and playing out in the street in Spanish and English, boisterous and loud. What was going on back home without him? Did anything change? Did anyone notice or care? He had been in Shanghai for almost a week and had not spoken to his parents. Did *they* miss him, at least? He just wanted to close his eyes and transport himself back to the Bronx, where even if things were bad at least they made sense.

"Give me a cigarette," he said.

Min looked at him, shook her head. "If you're uncle's already mad, it's not a good idea."

"So you're all talk, too," he said. He turned and went back inside.

He finished the dinner rush without incident, trading only necessary chatter with Min as he patrolled her section of tables. When she left for the night she did not say good-bye. He didn't care. He didn't care about anyone or anything in this place, Shanghai. Beautiful city my ass, he thought. It was like a prison—a big noisy, stupid neon jail where everyone smoked and talked out their ass (his uncle; Min; even the old man painter, he suspected, was full of it). Do my time and go home. Make money. His uncle still hadn't told him how much he would be making, nor had he given him even a few coins of pocket change. He wanted to pay off his debt to the school and be done with it. And then he would have to deal with Victor at some point. The clod would never let a grudge go. Face up to Victor, get my head kicked in, hope I don't get too hurt, and move on with my life. The trials seemed never-ending.

It was late when they got home from the restaurant. His uncle opened a beer, turned on the television, and plopped himself down on the sofa. It reminded Tony of his parents, how tired they always were, how hard they worked. His uncle worked hard, that was for sure. But it didn't mean he had to like him.

"Tony, come sit. I want to talk to you."

Great, he thought, another lecture. His life was filled with lectures. He couldn't wait to be old enough to be away from anyone and everyone who might possibly lecture him on any topic. He wanted to live on a mountainside in a shack by himself where he could lecture the birds and sky and trees on how boring and stupid and useless lectures really were, and not have to hear a damn thing from anyone else.

"I spoke to Master Zhu," his uncle said. "You are going to work with him a few days a week instead of going to the restaurant with me every day. I can tell you're miserable, and you owe Master Zhu for stealing from him."

He looked at his uncle, tried to process what he was being told and come up with a proper response.

"What kind of work? Am I going to be his servant?"

His uncle sighed, then rubbed his hand over his face. "Do you act like this with your parents, too? Everything I say, it's like I'm attacking you. Do you even listen when people talk to you, or are you programmed to just snap back?"

"I'm listening," Tony said. "I just don't understand what I'm supposed to do, working for the old man."

"Stop calling him 'old man.' He's Master Zhu, whether you are talking to him or about him, even when he's not here. That man has seen and lived through more than you or I could ever imagine. You might talk to me like I'm your enemy, but you will treat and talk to Master Zhu with respect."

In the morning, after exercises and breakfast, they went straight to Master Zhu's house. His uncle said, "When you are done, take a cab back to the restaurant. You're working the dinner shift. And don't give Master Zhu any lip. You might not care about losing face, but I do."

Mrs. Zhu welcomed Tony inside and led him up to the studio, where Master Zhu was waiting for him. What was he going to be doing—cleaning brushes, or dusting, or organizing bookshelves? What kind of work could he possibly do in this place?

Master Zhu smiled and told Tony to sit. He closed the studio door. It looked exactly the same as it did the other day. He wondered what his uncle had said to Master Zhu, why he had not been given the chance to apologize when he was ready to. He was not so sure he was ready to apologize now, now that he was being forced to make amends.

Stupid brushes, he thought. He told himself he had to start making better decisions.

Master Zhu sat in the black leather chair, looking calm, peaceful, as if some greatly satisfying accomplishment had already been achieved. Tony tried to look down, but no matter how much he dipped his head he could still see the old man before him, half-smiling, waiting. He looked at Master Zhu and said, "I'm sorry I stole the brushes. I…I don't…I just thought…" He was struggling to find the words in Chinese, doing the translation in his head under the pressure of watchful eyes. "I shouldn't have done it. You were very nice to me."

Master Zhu nodded. Then he said, "I wouldn't have noticed in a thousand years that those brushes were missing. I have plenty of brushes." He paused to sip his cup of tea. "You never explained to me what kind of artist you are."

Tony was surprised by the question. He thought about it for a moment, then said, "I don't think you'd understand."

"Why don't you try me," said Master Zhu. "I've seen a few things in my time."

"I don't know how to say it in Chinese. We use cans of paint, like this…" He raised his hand as if holding a can of spray paint, and made a hissing noise. "We paint walls, and trains. It's called 'graffiti' in English."

"Who is we?" asked Master Zhu. "Do you have many friends who do this?"

"Friends? No, not really. But there are a lot of people in New York who do it. At least there used to be, but not anymore. If you get caught, the police arrest you."

He saw the recognition in Master Zhu's eyes, his smile. "I've heard of this before. I've seen pictures. It's very…interesting. You would be arrested for painting walls and trains in Shanghai as well. But tell me, if the walls are so big, and the trains are always moving, how do you do it?"

Another pause. He thought for a moment that Master Zhu was teasing him, but his wide bright eyes told him that he was genuinely interested in a real answer.

"Well, *I've* never painted on a train before. I wish I *could* do a train, but you need to be really good. You can't just stand on a platform and do it in front of everyone. You have to sneak into places and watch out for guards. And the walls and buildings, well there are always people watching."

"But you painted the school wall, and your teacher's car. When no one was watching. So what stops you from doing other things?"

Tony felt a flip in his stomach. "My uncle told you?"

"Or else how would I know?"

"Why would he tell you that? I can't believe…He just wants to punish me, make me look stupid in front of everyone."

Suddenly, Master Zhu stood. "Come on," he said, "we're going for a walk. Oh, wait." He reached down, picked up a thin book with hard black covers and handed it to Tony. All the pages were blank inside, no lines, the paper heavy, like the one that had been taken from him back home. There was a small pencil tied to the binding of the book by a string. "You'll need this if you're going to be working with me."

Downstairs, Master Zhu told his wife they were going for a walk.

"Are you sure? It's so hot out," his wife said. "Give me a second, I'll come with you."

"I'm fine," he said. "I have my young assistant to help me. We're going to talk, man to man. Show him the real Shanghai."

As they left the house, Tony looked back and could see the worry on Mrs. Zhu's face. "Don't be gone too long," she said. "It's so hot out—be careful!"

They walked on the main road lined with trees, past the big houses. Master Zhu looped one arm through Tony's, taking slow steps, carefully balancing with his cane. It was still hot, but Tony was not sweating so much. Together, he and Master Zhu matched a measured steady pace.

"So what do you think of Shanghai? Not much, eh? I can see it in your face."

"It's just different, that's all." He didn't know how much he was or wasn't supposed to say to Master Zhu.

"You miss home?"

A pause, then Tony said, "Yes, I do."

"What's it like? Your parents, what do they do?"

"They run a restaurant."

"Like your uncle."

"Smaller than my uncle's."

Master Zhu said, "Your uncle's restaurant is one of the best in Shanghai."

"It's very busy all the time," Tony said.

"Everywhere is always busy in Shanghai. Shanghai never sleeps."

"That's what they say about New York—the city that never sleeps."

"Makes things interesting, don't you think?"

Tony did not respond. Master Zhu stopped and pointed with his cane at the houses around them.

"You see how different they all are? The architecture? Built by foreigners, some almost one hundred years ago. French, Germans, British, Americans. They all used to live around here. The French alone had their own section, took up nearly a third of the city. Shanghai has always been a very popular, famous city with Westerners." They continued walking. Master Zhu went on. "Then the big war came. The Japanese tried to take over, ran everyone out. It was a hard time. But surely you know about this. I don't want to bore you."

"Know about what?"

"The war, and Shanghai. Your family is from here, aren't they? Certainly they have told you stories."

"About Shanghai? No, not really…"

"Not even your uncle?"

"He talks about skyscrapers and airports and how much money it's going to make him." He thought Master Zhu would laugh at this, but he didn't. They kept walking, turned off the main street and into a series of side streets. There was no market, no open stands or vegetables in baskets or wares being sold. Just people and old buildings. More laundry hanging. Broken brick and concrete, chipped paint and stucco and tile. People on the street smiled at them and said hello. "Teacher, how are you? Master Zhu, is that your grandson from America?"

"Not my grandson. Just a friend." Master Zhu nodded respectfully to everyone as he passed. "This old neighborhood, this used to be Shanghai. Now it's all about big buildings, shopping centers, and apartments. Like your uncle says, I suppose. Okay, stop here."

They stopped in the middle of the street. There were no cars, only people walking, random bicycles streaming through.

"Take out your sketchbook," said Master Zhu. "Sketch something. Anything you see."

"Right here? Now?"

"Yes. Do it."

They stood off to the side, away from the bicycle and foot traffic. The air was feeling hotter now, that pungent gutter stink creeping up into Tony's nose. He wondered if Master Zhu could smell it, if it bothered him. He let go of Master Zhu's arm and looked around. The sun was blasting over the rooftops of the old buildings, cutting the sky in half like a saw of light. Then he saw from the corner of his eye an old woman standing alone against a cracked and crumbling brick wall, her body and face half-hidden by shadow. Her hair was white, the skin of her face golden and wrinkled. She wore a thin dark coat that was too big for her, the sleeves rolled up,

showing her frail veined fingers and wrists. Her eyes were narrow watery slits; she seemed to be frowning, wringing her bony hands together as if worrying, fretting over the return of a loved-one long since departed. Tony began to draw. He started with her face, her hair. He traced the outline of her body and clothes. She had no shoes on. He wanted to get closer to see her more clearly, but when he began to move Master Zhu put a hand on his shoulder and held him in place.

When he finished, he opened the book so Master Zhu could see, but Master Zhu turned away. "Alright, let's go back to the house and get a drink. But this will be your assignment—I want you to sketch at least one new thing every day. I don't care what it is—a person, a building, a bird, a bicycle, a car. Something, anything. But at least one thing new every day. Understand?"

"Yes, Master Zhu."

"A singer must sing, a writer must write. A painter must paint—and sketch, sketch, sketch." Master Zhu looked into Tony's eyes until they both nodded in silent agreement. Then he looped his hand back through Tony's arm for the short walk home.

CHAPTER 10

The next day, Master Zhu's wife called and said that Master Zhu had a cold and would not be able to see Tony again until after the weekend. He felt disappointed, but what could he do? "Don't worry," his uncle said. "I'll make sure you don't get bored." He had not told his uncle that Master Zhu had given him a new sketchbook, even though he knew he should, lest his uncle accuse him of stealing it. But he liked the idea of a secret between himself and Master Zhu, a tacit bond.

Standing outside the restaurant with Min during a break, she asked him what he was carrying around. He showed the book to her, but did not show her the drawings he had already done.

"Here, I'll draw you," he said.

"No, no, no," she said, turning away, holding up her hand to block her face.

"How are you going to be an actress if you don't like people looking at you?"

"I want to be on television, or in the movies. I don't like pictures."

"Don't worry, I'll make you look like a movie star." He opened the sketchbook to the next blank page. Min yelled at him to stop, but he

ignored her. Then she stopped yelling and continued smoking her cigarette. He kept peeking up to take glances at her. She was smiling now. She looked so pretty with her hair tied back, her red dress standing out against the blur of concrete and neon behind her. When he finished the sketch, he showed it to her, watched her eyes grow wider, her mouth open just a bit.

"Very nice, Tony from America. Maybe you have some talent after all."

She gave him a cigarette, lit it for him. He breathed in, trying to act natural, as if he had done this before. He held the smoke in his mouth, felt it like a hot ball of dust and dirt creeping down his throat. Disgusting, he thought. He took three more drags, the burn getting worse each time, fought the urge to cough and spit, then nonchalantly flicked the half-smoked cigarette on the ground.

His breaks with Min aside, he did not have time to sketch, so each day he kept a mental log of images: an old woman in a wheelchair wearing a plastic bib, being fed soup by her older son; a little red-faced girl with a doll, crying, arms crossed, refusing to eat; a young couple in the corner, smiling and giggling, holding hands across the table, their legs crossed at the ankles beneath. Lying in bed each night, instead of playing with his Gameboy, he drew from memory as much as he could. He drew the dumpling ladies, the stray hairs that escaped their hairnets and hung in their eyes like a spider's legs; or his uncle, in a dark suit with a bright wide tie, huge half-moon smile tearing across his face. He drew the cooks as they came out after the lunch shift and congregated at the table, heads bowed as they wolfed down their food. He drew the old people in the morning doing tai-chi like statues; drew the landscape of the city, towers like spears ripping the sky.

He felt it like a transfusion of new blood, the shock and current he used to feel sketching, drawing, planning; the weight of the book in his lap, the grip of the pencil between his fingers, the scratch and swish of lead on paper with each new angle and line. No longer was he thinking of a tag or alter-ego or scheme; he was just drawing what he saw, as Master Zhu had

told him to do. To each sketch he added outline and shadows as needed, thought what he was doing was good, different from anything else he had done before.

One night over the weekend the phone rang; they had just come home from the restaurant. His uncle answered it, and Tony knew right away it was his parents.

"I want to talk to them," he said. He sat down next to his uncle on the couch so he would hear anything that might be said about him. Then his uncle handed him the phone. His mother was on the other line.

"Hi, Mom."

She asked him how he was doing in the heat, if he was eating okay, if he was enjoying Shanghai so far. "Yes, yes, it's fine," he replied. She sounded anxious and tired, talking so fast, spitting out a new question before he could answer the previous one. When his father came on, he asked, "Are you working hard? Don't give your uncle any problems. He's a busy man. He's doing us a favor."

Some favor, Tony thought, but he simply said, "Uh-huh. How are you doing? How's the restaurant?"

"We're fine. Everything's fine," his father said in his usual stoic manner. He waited for his father to bring up the accident at the restaurant, or for his mother to come back on the line and chastise him or warn him about living in the big city. He could hear her in the background yelling something to his father, the splash and sizzle of the bustling kitchen, the other phone line ringing.

"Your mother says don't forget to ask your uncle to bring you to pay respects to your grandparents. It's important."

"I know, Dad."

"Okay, we'll talk to you soon. Be good."

"Love you, Dad," he said in English, but his father had already hung up.

He handed the phone back to his uncle and got up and went to his room and closed the door. His feet hurt, and his stomach was rumbling. He

could still hear his parents' voices in his head, the sound of the kitchen and restaurant behind them. Life was going on without him; he thought it amazing that he could feel so close to one world while existing in a completely different other.

A few minutes later, he went back outside. His uncle was drinking a beer and smoking, half-asleep in front of the television. "My parents want you to take me to pay respects to my grandparents."

His uncle looked at him bleary-eyed. "This weekend? No, too busy. Some other time."

"I'm just telling you what they said." He went back to his room and lay down and tried to sleep, willing himself to dream of Min, and not the restaurant and his parents and all that he missed back home.

His morning exercises began to feel easier: he could now do more than twenty push-ups and sit-ups in a row, and the jog around the complex no longer made him feel like he was being stabbed in the abdomen and lungs. His pants fit more loosely, his gut no longer a round ball of jiggling fat, more like an extra coat of insulation. Looking in the mirror, he thought his face looked a little thinner as well. Was it true, or was he so hungry and tired all the time that it was now affecting his imagination?

He went back to Master Zhu's house the following week with more than ten pages of his sketchbook filled. In the studio, he asked, "Are you feeling better, Master Zhu?"

He smiled at Tony and nodded. His eyes looked watery, pink. Between his drawing table and the black leather chair, he moved slowly like a crab in wet sand.

"I'm fine," said Master Zhu. "When you get to be my age, it's easy to get tired. Well, let's see what you've done."

Tony handed the book to Master Zhu, who spread it open in his lap and began to leaf through, his eyes focused, serious, betraying no thoughts or emotion. Then he looked up at Tony and told him to move closer so

they could look at the drawings together. He had flipped to the picture of Min smoking. He said to Tony, "What do you see?"

"A girl smoking."

"Right. But what do you *sense* about her?"

"I don't know," Tony said. "She's very pretty."

"Are you saying she's pretty, or are you looking at the picture and thinking that she's pretty?"

"I don't know. I mean, I know her. I think she's pretty."

"Stop thinking," said Master Zhu. He flipped to another page. "What about this one?"

"Women making dumplings."

"Why did you choose them as your subject?"

"I work with them. I see them every day, and..."

"Is that what makes them special? Look at the picture. What stands out? What does this picture make you feel?"

He looked down at his shoes, began to feel that hot burning pit in his stomach. "I don't know what you're saying, Master Zhu. You told me to draw something new every day, and I did. I worked hard on these. I tried to make them look as real a possible."

"Real in what way? Why does it have to be real?"

"Why? I don't know. I just did what I thought you wanted me to do."

"What *I* want you to do? What about what *you* want to do? You said you were an artist, a painter. But looking at these drawings, all I see are clusters and piles of lines."

He didn't understand why Master Zhu was prodding him like this, peppering him with these questions, back and forth. You asked me to draw, I drew, he thought. What else do you want from me?

Master Zhu said, "When you painted your teacher's car, did you paint what was real?"

"What?"

"Or what you painted on the school wall—was that real?"

"How...who...did my uncle tell you *everything*?" He hadn't known that even his uncle had been given such details. Sweating, he wanted to get up and storm out of the studio, out of the apartment. It was part of the plan—his parents', his uncle's, whoever—to keep humiliating him and beating him down until he simply gave up and conformed without resistance.

"I am simply trying to make a point," said Master Zhu. He picked up a book from the end table next to him. "I found a few books on this art of painting trains and walls. How do you say it in English?"

"Graffiti."

"Yes. Well, I like it very much. The energy, the vision—I don't understand the words they write, but I can still feel the life inside those words. That is the most important thing in art, to create something that is living, that has vitality and yet feels natural. The colors, the shapes, I love the different images and techniques and styles. But especially the colors—they must look beautiful when they are in motion."

"They used to," Tony said.

"To think, using trains as canvases—only in America."

Master Zhu put the book back down on the table and picked up Tony's sketchbook again. "Your drawings, on the other hand, are flat. No energy or life. It's like you have frozen your subjects in time, sucked the life out of them. These cold depictions do not live off the page, as they should." He came back to the picture of Min, looked at Tony to make sure he was still paying attention. "This girl, she is pretty. You know her in real life—so does she look flat when you stand next to her? When you talk to her? No, of course not. You drew her because there is something special about her that you see. So, what is it? It must come out in the drawing. Someone looking at your work must feel a little bit of what you feel, even if they cannot quantify with words those exact same feelings. Maybe they will feel something else, something different. But they must feel something.

"Look at the picture. You say she is pretty. But I look at the picture and see a round face and a cigarette, pigtails. I see a scratchy blur behind her.

She could be standing in a forest, or in the middle of a street. I don't think, 'pretty.' I don't think, 'beautiful.' I think, 'lines, lines, lines.'"

Master Zhu began flipping back and forth between pages. "These women making dumplings, to me they look sad. Do you think they are sad?" Before he could answer, Master Zhu said, "Don't answer that. It is only something I want you to think about. When you are drawing or painting, you must not think too much about what it is you are painting. If you think too much, then you will begin to analyze. You will try to do something that you think you should be doing, or something you think you want to try to do. But by then you will have lost the focus necessary to do what it is you *should* be doing. That is what is most important and what is hardest for an artist—to find that space in which he can identify the work he is meant to do, and stay in that space to actually do it."

Tony's head was spinning now, all this vague philosophy. He wanted to draw and paint, that was all he wanted—be creative, express himself. Be unique, original, noticed for his work, not like everyone else. Instead, he was being lectured again.

"Master Zhu," Tony said, "I don't understand what you're saying. I don't want to draw or paint like you. Copying is not creative. I've seen your paintings. I think they're good, but I'm trying to do things my own way."

He looked at Master Zhu, expected to see aggravation, irritation in his face, but he did not. Master Zhu was looking at him, listening. His eyes were bright and clear. He rubbed his beard slowly, softly with his hand, nodded. He flipped through the pages of restaurant scenes that Tony had sketched.

"You are right," said Master Zhu. "Copying is the least creative thing. But that is not what I'm asking of you. Look at your drawings. You see the bodies, but there are no backgrounds, and the faces all look the same, like you're drawing stick figures. Are you trying to be minimalist, or are you just being lazy? Where are the noses, eyes, mouths, ears—where are the details that make people ugly and beautiful?"

Tony shrugged. "Maybe that's my style."

"Your style is drawing people with no faces?"

"Maybe."

"If you are not sure, then it is not your style. Style for style's sake is not style. It is artifice. It is distraction. Every element of a painting must work together in harmony, balanced."

Tony had had enough lecturing, enough philosophizing. If this was what it was going to be like, he would rather work in the restaurant, where he could smoke cigarettes and spend time with Min. Being criticized in the restaurant for being fat or slow or lazy or just plain stupid, he could deal with—being criticized for his drawings, he could not.

"Master Zhu, thank you for buying me this book. I appreciate it. But you're...well, you're an old painter, and I'm a young one. You're Chinese, and I'm...well, I'm Chinese, too, but I'm also *American*. I don't think we have anything in common. I don't want to waste your time."

Master Zhu paused, looked at Tony, then looked away and sighed. "If you are so ready to quit, then you are right."

The air was suddenly hot, and the flat look on Master Zhu's face made Tony feel as if he had already left the room. He fiddled with his cane and began to rise from the chair. Tony went to help him, but Master Zhu was already standing on his own.

Tony said, "What about the brushes?"

"What brushes?"

"The ones I took from you."

Master Zhu nodded. "Your debt is paid. If you will excuse me, I have some work to do. Please tell your uncle I say hello."

CHAPTER 11

He spent the morning making dumplings, then working the lunch shift, all the while with a nagging feeling like a jagged stone lodged in his chest. At the end of the shift he told his uncle that he was going to Master Zhu's.

"Wait a minute," his uncle said. He ducked into the kitchen and returned with two hot cartons. "Bring these to him. Tell him, 'thank you.'"

From the restaurant he walked down Nanjing Road, felt more comfortable now in the swarm and rush of bodies and bicycles and cars. All the street signs were in Chinese, so he could not read them, but he had tried to remember the way by landmarks that would tell him when to turn left or right. Back home in New York, the streets and avenues were essentially on a grid, hard to get lost, but here everything twisted and wound like a pit of snakes; one wrong turn, and who knew where he'd end up. Worse come to worst, his uncle had written down Master Zhu's address on a business card, and he could ask someone for directions. He passed a row of empty handcarts chained to a rail, then a man who seemed to be hiding behind a wall of sugarcane stalks. "Juice," the man called out. "Sugarcane juice!" He looked right at Tony as he passed, but Tony kept on walking.

Eventually, he found Master Zhu's house without getting lost, was

proud of his memory and ability to navigate. When he knocked on the door, Master Zhu's wife did not seem surprised. Tony handed her the two cartons of food. "For you and Master Zhu."

She smiled, thanked him and said, "Let me make sure he's not working." When she came back, she nodded, and Tony made his way up the stairs.

In the studio, Master Zhu did not look surprised to see him either. "My young American friend, my wife says you brought me lunch." He was standing at his painting table, brush in hand, eyes trained down. Tony did not know if he should sit or continue to stand. He waited for Master Zhu to stop painting before he spoke.

"I'm not a quitter," Tony said.

"Excuse me?" Master Zhu was looking at him now.

"Yesterday you said I quit easily. I don't."

"But you did."

Tony looked down at the floor and kicked his feet. "Well, right, but… I was just…I thought my drawings were good, and you didn't like them. I was upset."

"Bad temper," said Master Zhu. "A privilege of the young."

Master Zhu looked back down at the painting he was working on, contemplating. Tony remained standing and decided he would stay there until he was told to leave. Then Master Zhu waved him forward. "Come look at this."

Tony walked over and stood next to Master Zhu, stuffing his hands in his pockets to avoid knocking anything over. On the table was a painting of blue-and-gray mountains crowned by pale clouds, a drifting mist seeping and fading all around. There were trees, and at the base of the mountain was a riverbank where tiny boats seemed to be sailing toward shore with splashes of color, hues of gold and green.

"What do you think?"

"I like it," Tony said. In the background, the shapes of the mountains were less distinct: like the clouds, there was no outline or tracing, only the

faded shape of hulking stone giving the sense of deep distance. Up close, he saw a village tucked away in front of the mountains by the water.

Tony helped Master Zhu over to his chair. They sat, and Master Zhu said, "I'm sorry I was so hard on you yesterday. I realized it after you left. I haven't taught anyone—especially someone so young—in many years. I was a college professor for a long time, I should have known better. I forgot how hard it is for young painters to listen to criticism."

"But you were right," Tony said. "I can do better."

"That's why we do them over and over again." He smiled, and said, "I've done a thousand landscape paintings in my life. Never the same mountain or river or lake or stream, it is always different. Even if I look at a painting I once did, when I see it again, in my mind it is different. Because the mountains are alive. The rivers and streams, all living, changing, even though they appear to be constantly the same." He sipped his tea, then continued. "While you are here I can teach you some things about Chinese painting. It is very different from the kind of painting you're used to, but maybe it will help you with your own art, don't you think? It must be better than being cooped up in a restaurant all day."

"It is," Tony said, "much better." He felt himself smiling.

"It's agreed then. But let me say this before we start." He fixed Tony with his eyes. "At times it will seem like I'm trying to teach you to paint like *me*, but really I'm trying to teach you to paint like you, to find your own way. Because when you leave this studio, it won't matter who you've studied with. An artist is only defined by his work. Nothing substitutes for the work itself."

Then he said, "Go back to the restaurant. I want to try to finish up that piece. I've been slaving over it too long already. Come back tomorrow afternoon, and we will begin."

Going back the next day, Tony wondered if Master Zhu would have a separate table or space set up for him to paint, but when he went in the studio

he found Master Zhu sitting in one of the black leather chairs, leafing through a book. He gestured for Tony to sit.

"Are you ready?"

"I am," said Tony. He thought he might need to take notes, so he opened his sketchbook in his lap, but Master Zhu told him to close it.

Master Zhu said, "Just listen. I think you need to understand a few things before we begin."

He sipped his tea, cleared his throat, and began. He told him how painting had been a part of Chinese culture and society for over three thousand years, how artists through the centuries would work in the courts of emperors, painting scenes from daily life, a kind of tribute and record; how painting, even today, was called "the three perfections," where the three arts of the brush—painting, calligraphy, and poetry—came together.

"Chinese painting is very different from the West," said Master Zhu. "We use ink, not oil, and we paint on paper, not on canvas. But the biggest difference is the vision, how we see things. Here, look at this." Master Zhu opened a big book in his lap and began flipping slowly through the big glossy pages, stopping after every few. "These are some of my favorite Western painters. Matisse, Cezanne, Van Gogh. Picasso, of course. Beautiful, yes? Such detail, such colors. When you look at these paintings, you feel like you're standing still and looking through a frame and into the world of the picture. Almost like you are standing inside the picture, but just a different space that is not actually part of the painting. Do you see that?"

Tony stared at the paintings in the book and nodded. Master Zhu went on.

"Chinese painting does not do that. You see how the objects in these paintings have shadows? That means that the light inside the picture comes only from one place. But Chinese painting does not utilize the idea of one fixed light source. The light can come from anywhere, as long as it enhances the painting. Now look at how these backgrounds are filled in with color, even when there is really nothing there. Yellow skies, blue skies,

green skies—again, Chinese painting does not do that. Not everything is rendered realistically, three-dimensionally, with precise size and shadow and shape. Chinese painting is more free, more open. The purpose is to show the subject you are painting as it exists in reality, but also as it exists in the painter's mind. So it is an imagined likeness, not a strictly realistic one. We are trying to capture the essence of the thing you are painting, which allows room for the painter's interpretation. A more spiritual expression. You can tell very much from not only what an artist paints, but how he paints it.

"Here," said Master Zhu, "look at this painting I just finished. I haven't titled it yet. I haven't written a poem for it either. But look at the difference."

They stood and walked behind the painting table where the painting that Master Zhu had been working on the day before now hung drying on a line. Mountains and clouds, the water and village and boats, there was more color now—the trees at the base of the mountain seemed to burn from a cold clear blue to a deep fiery red. The mountains bled from blue to gray to green. The mist crowning the mountains was simply clear white, as was the water, no color or outline or trace of shape necessary.

"Let the empty space work for itself. The space will create the image of sky, of water, whatever the context of the painting will imply. See the difference?"

"The boats are so small. So is the village," Tony said. He also noticed that there were no actual people in the painting. It was like staring at the scene from a place high in the heavens, like a bird flying above. He wished his Chinese were good enough to explain what he was thinking.

"It's very beautiful," Tony said. Then Tony asked him, "What else do you paint, besides mountains and rivers?" For a second, he thought it sounded like an insolent question, but Master Zhu did not take it so. He stood there thinking, smiling.

"It's a hard question to answer. I suppose I paint what I appreciate, subjects that bring me joy. Simple things—a plate of crabs, a cluster of

grapes or flowers, a jug of wine. Everyday things give me pleasure, and inspiration."

"Have you always painted like this?"

"No, no," said Master Zhu. "I started when I was very young, much younger than you. But that is a longer story—I will tell you about it some other time. For now, let's concentrate on you."

"Okay," Tony said. "So what do I paint then?"

Master Zhu laughed. "How are you going to paint if you don't know how to use a brush?" Pointing at the table Master Zhu said, "These are your tools—brushes, ink stick, ink stone, paper, water. And of course, your studio, a place where you can clear your mind and concentrate on your work. My studio is my haven. It has always been, no matter where I've lived. I can block the outside world. It is necessary for an artist to have his own space."

He explained to Tony the difference between hard and soft brushes (hard brushes for thin straight lines, soft brushes for broader, softer strokes), explained to him how to grind the ink stick against the ink stone and how to mix with water. "The paper is a special paper—very raw, absorbent. But it is not rice paper, as many people believe." He spread a clean sheet over the table, then took a brush and dabbed the tip with ink. "First we learn to paint a line." He handed the brush to Tony.

"A line? That's it?"

"You say it as if painting a line is simple. But it's not. Let me see how you hold the brush." But before Tony could even get his hands into the shape of a grip, Master Zhu was pulling and molding his fingers.

"Relax your wrist. Remember, you are not holding a pen. The fat tip of your thumb and your pointer and middle finger hold the brush. The edge of your ring finger against the side. There—see the hollow space between your thumb and other fingers when you hold the brush? That means you are doing it correctly.

"Hold the brush so that it is straight up and down. This way you control the head with pressure, angles, speed, for different effects. Okay. Now

I want you to paint a line."

Tony looked at Master Zhu with an eyebrow raised. "Just a line?"

"Yes, a line across."

Trying to focus on the form of his hand, he pulled the brush across the page.

"There," he said. "A line."

Master Zhu nodded and smiled. "There is much to learn, my young American friend." He took the brush from Tony and gestured for him to step aside. He dabbed the brush with fresh ink, then painted a line directly beneath Tony's. He moved as if in slow motion, his head aligned directly over his brush hand from beginning to end. Then he stepped back and said, "When you paint, it is like a dance. It is not only the movement of the arm or the wrist—it is your entire body. You start with your shoulder, which moves your arm, then your hand. Then you shift—slowly, very slowly—from one foot to the other. But you can't think too much about it. It has to flow, feel natural. But it must incorporate your entire body, or else your painting will lack power, lack strength. And even a simple line will lack the vigor and energy necessary. Look at the difference between our two lines. Do you see?"

The line that Tony had painted was thin, dark at the beginning, lighter and thinner in the middle, then just a faded wisp at the end. Master Zhu's line was dark and steady, even, solid throughout.

"It's called 'bone structure.' All good strokes will have strong bone structure."

Tony nodded.

"Good. Now do it again. Try to paint the perfect line. Remember, bone structure. Holding the brush, moving with the flow of your body. There is a rhythmic vitality you will sense and feel when you are flowing. Try to paint each line in one big breath—this will control your energy. It all comes alive in the painting. You'll see. Now go."

He left Tony standing at the table, and as Tony painted, Master Zhu sat reading. They did not speak. Soon his arm began to tingle and burn from

holding the brush in one position, but he tried to block away the pain. He concentrated on keeping the space between his thumb and fingers as he gripped the brush, as Master Zhu's words floated in his head: energy, spirit, bone structure, dance, strength, flow....

After a while, he seemed to forget that Master Zhu was even in the room with him. He could see it, feel it, his lines were getting stronger, better, more consistent. He began turning the brush as he worked, angling the head, spinning it for different effects. Like a spray can, he thought, how he could manipulate the richness and texture of lines with such simple moves.

Master Zhu came back to the table to see what he had done. Tony stepped aside and felt suddenly nervous. But Master Zhu smiled and said, "Better—much better. I see you began to experiment. Very good. The brush is a miraculous tool. It is an instrument, really, capable of so many things.

"Good," he said. "You've done enough for today."

"But we just started. "I want to do more."

"You've been working on your lines for two hours already."

Tony looked at his watch, amazed at how quickly time had gone by. Master Zhu handed him a thin book with a glossy painting on the cover. "This is a small catalogue of my paintings that a friend of mine in New York put together. Look this through, if you want. Just something to think about until we get together again."

That Saturday, they woke up early in the morning, and his uncle told him to put on his best clothes. It was still the middle of summer, the humid air thick like glue. He put on a short-sleeve, button-down shirt and a clean pair of shorts, along with the new sneakers his mother had bought him that he'd barely had the chance to wear. When he came out of his room, his uncle looked at him and scowled.

"You don't have pants?"

"Uncle, it's so hot outside."

"Fine, fine," his uncle said. "Let's just go."

Outside, they got in his uncle's car and drove. He was smoking, as usual, the air in the car swirling with ashes.

"Where are we going?" Tony asked.

"To pay respects to your grandparents."

"Oh," he said. He wasn't sure how to respond to this, whether he should feel happy or sad. They drove for over a half hour. He looked outside at the passing buildings and houses and trees. They had left the city, were in the outskirts, the suburbs now. Then his uncle said, "You're doing much better at the restaurant. Everyone says so."

"Really? I didn't think anyone cared."

"Of course they care. I'm the boss—they notice when my nephew is working. Especially after the accident, everyone was watching you. I'm not telling you this to frighten you, I just think you should know. This is how the real world works."

"Right," Tony said. He had been hearing about the real world now for some time—from his parents, his uncle, his teachers. If they keep talking about the "real world," he thought, then what world am I living in?

They kept driving. Tony said, "When did Grandma and Grandpa die?"

His uncle looked at him as if he had cursed their names aloud. But he said nothing. Tony watched his face turn red as he lit another cigarette with one hand, the other bracing the steering wheel.

"You really know nothing, do you?"

"I was just asking a question…"

"Your parents have never told you anything?"

Forget it, Tony thought. I'm just going to keep my mouth shut.

Then his uncle said, "Your grandparents died more than twenty years ago. Nineteen seventy."

"Did they live all the way out here?"

"No, they lived in the city. We all did."

"Then why are we coming out here?"

His uncle sighed and said, "Dumpling, please stop talking. You're

making my head hurt." He took a long drag, then filled the car with exhaled smoke. Tony coughed. He thought his uncle was doing it on purpose, trying to choke him out.

They drove another fifteen minutes, had entered what looked like a small town—storefronts and shops opening as they did every day on the main streets of Shanghai, except here there were no armies of uniformed staff, only a random man or woman on the sidewalk carrying a few boxes, scrubbing objects in a steel bucket, flapping out and hosing down mats, or rolling up curtains and blinds. They pulled over on a side street lined with small buildings, and as soon as they stepped out of the car Tony could feel the difference between here (wherever they were) and the downtown hustle of Shanghai: no buzz in the air, no shriek of horns or engines cranking, cranes screeching, voices blathering. Quiet and peaceful, it reminded him of home on early weekend mornings when he would get up to draw or steal a few minutes of painting on the roof.

From the backseat his uncle grabbed a big paper bag and handed it to Tony. "Carry this," he said. "Follow me."

They crossed onto the main street and walked beneath a big iron-and-stone arched gate. The sun was shining high and hard, and following behind his uncle, Tony felt himself sweating to keep up. He noticed his uncle was not smoking now. All around them he saw what he thought were headstones. Not like headstones he had seen at the cemetery back home, short and rounded at the top or squared off, simple and plain. It was almost like a park, with patches and stretches of grass and paved paths leading to and fro between monuments: tall, ornately carved stones, row after row of tombs with Chinese characters engraved.

As they walked, stopping a few times to look around, his uncle said, "We were very poor when your grandparents died, so we buried them out in the countryside. It was a beautiful spot, on a hill. Your mother would remember. But a few years ago, they opened these public cemeteries. So I moved them here. I wanted to honor them."

"My mother's never been here before?"

"No," his uncle said.

Tony wondered if there was a camera in the bag he was carrying, but before he could ask they stopped in front of a wide, white stone that was almost as tall as Tony. He wasn't sure what to call it—a stone, a monument, a tomb. The top of the stone was like a mantel carved with blooming flowers, the base lined with columns of Chinese characters. He wondered what it all said but was afraid to ask. His uncle took a deep breath, a pale pink color in his cheeks. He stood with his arms hanging at his sides, slouching, looking down.

"Give me the bag," his uncle said.

Tony handed it to him, and his uncle began to withdraw its contents. He handed Tony a cluster of incense sticks, then pulled out a plastic bowl filled with apples and oranges and pears. He laid the bowl of fruit on the grass at the foot of the monument, then lit the incense Tony was holding, taking a few sticks for himself. His uncle turned to face the monument and Tony did the same, following his uncle's every move as he bowed with both hands clasped before his face, eyes closed. His uncle was muttering a chant of some kind, a prayer, but he could not hear clearly what he was saying.

Tony bowed and said a prayer to himself, for his grandparents: I'm happy I am here—thank you. Bless you. My mother misses you very much. I never knew you, but I know you were good people.

Then his uncle was on the ground kneeling and bowing, hands still clasped, still holding the burning incense, and Tony fell to his knees and did the same. Then they were standing again. The last thing his uncle pulled from the bag looked like a small wad of gold-and-red money. He peeled off a few sheets, lit them and held them burning until the flame was close enough to singe his fingers. Then he let go, ashes riding the wind. Tony took some of the money, and his uncle lit it for him to do the same.

His uncle's eyes were veiny and red. He said, "Usually, we come in the spring, for Tomb Sweeping Day, when we pay respects, bring gifts, say

our prayers. Your parents never taught you about any of this?" Tony looked straight ahead, did not answer. His uncle continued. "But you're here, and I thought you needed to do it. Your mother wanted you to, and I'm glad you did. You did it right."

On their way back to the city, his uncle said, "Your grandparents, they were very poor in life, so I want them to be as comfortable as possible in the afterlife. That's why I moved them. That plot where they are buried, that stone—it's very expensive. But they deserve it. It's important to be rich, even in the afterlife."

Tony nodded. He was thinking many things: missing his mother and father, wishing they could have been there with him; wondering why his uncle was an older man and yet seemed very alone—no friends or girl-friends, no wife and kids; how the cemetery was very beautiful and very sad at the same time. A field of statues dedicated to the dead.

When they had gotten back to the city, he thought they were going back to the apartment or the restaurant, but they made a turn and Tony did not recognize the streets around him.

"Don't we have to go to the restaurant?" he asked.

"Later," his uncle said. "First I want to show you something."

They found parking in a lot, then walked for several minutes, past long rows of old parked bicycles, none of them locked or chained. His uncle's pace was urgent, quick, as if he were late for a meeting. The street seemed to close up around them. On both sides were shining red buildings with arched and slanted terra-cotta roofs, red-and-gold banners and flags hanging and flapping overhead. Peddlers with their carts selling food, drink, trinkets, shopkeepers calling out bargains. Then they came into a clearing filled with small packs of people, some being spoken to via mega-phone, others standing patiently, waiting, with one member up front car-rying a small colored flag. Voices at full throat. Tony stuck behind his uncle, did not want to get lost in the crowd.

"Tourists everywhere," his uncle said. "Especially in this area, here to

see the tea house and Yu Garden. This part of town is called 'Old City.' It's where only Chinese used to live, when there used to be so many foreigners in Shanghai. Come on, keep up."

They squeezed past all the tourists, onto a street lined with tables and blankets on the ground filled with small statues, paintings, vases, carvings, various designs of ivory and jade. They passed an old man playing an odd instrument like a stick with two strings held upright and played with a bow. It sounded like a violin, but higher pitched, whinier.

"Why are his eyes closed?" Tony asked.

"He's blind," his uncle said as he threw a few coins in the box at the old man's feet.

They followed a tangle of narrow stone-paved lanes with walls and gated entryways on each side. Then there were buildings the likes of which he felt he had seen before on his walks to and from Master Zhu's house, in the backstreets where neon signs did not shine and the roar of crowds fell mute on stone. Laundry dangled off terrace rails or out of windows, flying on lines between buildings across the narrow street. His uncle's pace slowed; he could feel eyes all around them staring, watching. Two chubby-faced boys with crew cuts and dirt-smudged faces were dueling with long thin sticks; a mother washing her baby in a small tub, a woman cutting vegetables on a plate; old men playing cards on a small fold-out table; old women sitting, smoking, chatting, doing nothing. The buildings were so old, façades gray and smeared black like the ash of fire, cracked wood-frame windows and red rusty doors. Some of the roofs seemed on the verge of collapse, piles of brick and stone. Ragged awnings hung here and there, hard to tell which door led to a home and which to a store. The smell of the gutter running alongside the street. So old, the buildings seemed to sag together like tired soldiers, one holding up the next.

"Uncle, why are we here?"

"We used to live here, that's why."

"You lived *here*?"

"*We* did—me, your mother, your grandparents."

A man with small eyes and bronze skin rode by on his bicycle and spit very close to Tony's feet. He kept his head turned, looked Tony in the eye even as he rode away. His uncle did not seem to notice as he pointed at the house in front of them. The windows were boarded up, but Tony thought he could hear voices inside.

"This one, upstairs. It's only two rooms. We lived here until your mother met your father, and I moved out. Even after we had some money, I begged them to move, but they wouldn't. They said they were comfortable here."

His uncle had that look on his face again, the same look he had at the cemetery. He did not seem like the same person who walked tall and proud and barked orders in the restaurant, the one who smoked and arrogantly blew smoke in Tony's face. He looked younger, like a boy, sad and lost and scared, a look Tony had seen in the mirror countless times.

"I hate this place," his uncle said. He sneered, rubbed his eyes with a knuckle, then lit a cigarette. "It won't be here next time you come back."

"Why not?"

"Because they're going to build over it. I told you this before." They stood staring at the building a few seconds longer. Then his uncle slapped him on the shoulder and said, "Come on. Let's go."

They went back to the apartment. It was nearly noon now. His uncle picked up the phone, and by the tone of his voice, Tony could tell that he was speaking to his mother. His uncle would say something, then there would be a long pause. Then he would say something else. He called Tony into the living room, and Tony put the phone to his ear.

"Mom," he said in English. "Uncle took me. We saw…"

But all he could hear on the other end was the sound of his mother crying.

CHAPTER 12

When he went to see Master Zhu again, it was his wife who met him at the door.

"He's not feeling well," she said.

"Is he okay?" Tony asked.

"Just a cold. He needs some rest." She said, "I will call you when he's feeling better. For now, he told me to tell you to keep practicing. And he wanted me to give you these." She handed him three more thin catalogues of Master Zhu's paintings. She smiled at him and closed the door.

Walking back to the restaurant Tony was happy to have the catalogues, but at the same time he worried about his own work. How am I going to practice? he thought. He felt disappointed, but understood. After all, Master Zhu was very old. He couldn't imagine what it was like to be thirty, much less one hundred years old.

When he got home from the restaurant that night, there were brushes, an ink stick, ink stone, water cistern, and other materials on his desk, all brand new, wrapped in shiny plastic.

From his doorway his uncle said, "Master Zhu told me you needed these things."

"Thank you, Uncle." Tony turned to look at him, not sure what else to say, wanted to shake his uncle's hand or hug him, but he didn't.

"You just do what Master Zhu tells you," his uncle said. Then he turned and left.

He wanted to begin painting right away, but was tired from the day's work. So he lay in bed looking through the catalogues of Master Zhu's paintings. There were flowers and plants, fruit and dumplings, bamboo, bottles of wine, scrolls of calligraphy. Tony wondered why he chose these subjects to paint as he tried to analyze Master Zhu's brushwork and style. He admired the colors that reminded him of valuable jewels—deep rich green and amber mountains with warm bursts of crimson and gold. Stark black bones in the stalks and leaves of a bamboo plant, the strokes bold and sweeping; blue and yellow irises, plump purple grapes hanging from a twisted vine. The lines and strokes were broad and rough, not delicate and clean. The colors bled through the lines to create a kind of dreamscape blur, and this was what Tony liked most, how Master Zhu's painting was so fresh and free, vivid, unrestrained; the exact opposite of what he thought Chinese painting was supposed to be.

One painting in particular stuck out to him: a river streaming down from high out of the mountains, blue trees lining the ridges and devouring the hulking peaks and masses of earth and stone. In the water were five men, almost miniscule in the foreground, on rafts, navigating downstream, so tiny, oblivious to the vast stretches of beauty around them. In the background, a drifting mist over cold white mountains. He pictured Master Zhu at his table, eyes focused, brush in hand, swaying ever so slowly from foot to foot, side to side, using his quiet energy, his force.

The painting was titled *Deep In The Mountains*, done in 1974, three years before Tony was even born.

He arranged with his uncle that he would still wake up in the morning to exercise, but a couple days a week he would stay in the apartment and

paint instead of going straight to work.

"I'll be there in time for the lunch shift."

"You sure you won't get lost?" his uncle asked.

"I've been riding the bus with you for almost a month now."

His uncle paused, then said, "You're right. You're not a tourist any-more. Hold on to the emergency money I gave you. Don't go around wasting it."

So his uncle went to work and Tony stayed in the apartment, unwrap-ping and preparing all his new materials. It felt good to be alone, sur-rounded by a peaceful silence. He ate some cold leftovers to quiet the grumbling in his stomach, thought about what Master Zhu had said about having his own studio, his own space. He was ready to begin.

First, he tried to remember how to grind the ink, how much water to use, how much pressure to exert when grinding the ink stick against ink stone. Three, four, five times he varied the amount of water, testing the consistency of the ink, trying to find the perfect mix; each time it was either too coarse and thick, or too thin and soupy; and each time, he wound up carrying the inkwell like a bowl of soup into the bathroom and dumping it in the toilet. He tried again and again. He remembered how easy it had seemed when done by Master Zhu. How would he learn to paint if he could not even grind his own ink?

By his eighth or ninth attempt (he had lost count), he looked at the clock and realized it was already past ten in the morning. He had been playing with the ink for over two hours and had not painted one single line.

He went back to the bathroom and cleaned up the drips and splatters of ink he had made, then took a shower and got ready for work. Can't even make ink, he kept repeating to himself. At the bus stop, he felt stupid and hot. The crowd was not as big because it was later in the day, but when the bus came he still needed to push and shove his way on. He did not feel bad shoving strangers anymore, even old men and women, because they obvi-ously did not feel bad shoving him.

He told himself to forget about the ink, that this was his first day and he would figure it out, get better. He kept his eyes open, focused on the streets passing by, and when he saw the glittering row of neon he got off. But standing in the street, he looked around and realized it was the wrong stop, and the bus had already taken off, leaving a trail of black dusty smoke. Had he missed his stop, or had he jumped off too early? It looked similar—the buildings, the traffic and crowds and bicycles, but it was not where he was supposed to be. His first impulse was to call the restaurant or just flag down a cab, but he felt like he was close, could figure it out on his own.

He walked toward the neon, sure he could find his way, but soon he realized this was not Nanjing Road, and that he had no idea which direction he should go. He could not read the street signs, did not have a map, cursed himself for not going to Chinese school as his parents had once begged him to. He kept walking, searching for something familiar. All around him droned the sound of traffic. The buildings before him were so big, gray, industrial. A construction crew wearing yellow hardhats and orange vests milled about a worksite like an army of ants. He tried to keep walking to avoid being pushed and shoved, but was afraid of being carried in too deep by the flow of people, and who knew where he might end up. Even the cabs in traffic seemed to fly by, impossible to flag down.

Then he heard his name in English and whipped around to see who it was. A blur of faces, all black hair and dark eyes. He heard it again, and this time saw Min coming toward him edging her way along the sidewalk. She wore a peach-colored skirt and white tank top and big dark glasses that covered most of her face. He was surprised to see her in normal clothes, even though he thought she looked great.

"What are you doing over here?" she asked.

"Well…I think I'm lost." He felt stupid admitting it, hearing the words aloud, but was relieved to see a familiar face. "I was trying to find the restaurant."

"Don't worry," she said. "When I first moved here I got lost all the time." She took him by his hand and started walking down the street, wending their way through the crowd beneath the shade of trees. When they turned down a side street with less traffic, he thought she would let go of his hand, but she did not.

"I thought you were working today," he said.

"I had a fight with your uncle, so I didn't go in."

"Aren't you afraid you'll get fired?"

"No, I don't care." Then she said, "Hey, I've been meaning to tell you, you look good. You've lost a lot of weight."

Tony looked down and said, "Thanks," feeling happy that she recognized the results of his hard work, but still self-conscious and disappointed that she had obviously seen him as the new fat kid in the restaurant, and probably still did.

She smiled and squeezed his hand and said, "You're very cute. Are all the boys in America this cute? I might have to go there and find one for myself." She leaned in and giggled in his ear, and this made him feel a little better. He turned his head and tried to keep himself walking straight, the smell of her perfume filling his nose, making his stomach go warm and wormy inside.

"What happened with my uncle?"

"It's not important," she said, waving her hand in the air as if shooing away a pest. "How old did you say you were? Sixteen?"

Tony nodded, did not bother correcting her. "How old are you?" he asked.

"Nineteen," she said. "Well, I'll be nineteen in the fall."

He loved the feel of her hand in his, her smooth warm skin, grip gentle and soft; he prayed to keep his palms from sweating, did not want to gross her out. She kept looking at him and smiling that red glossy smile, a dazzle and shimmer in her eyes, her hair blowing in the breeze. He had never walked like this with a girl before, and he thought maybe she liked him—

or else why would she be so nice, so sweet, go out of her way to show him such attention? As they walked they bumped shoulders every few steps, and he made a note not to squeeze her hand too hard, trying to stay cool and calm, as if he had done all of this before.

The longer they walked, the slower they seemed to go, as if they were on a casual stroll and just enjoying the passing time. He wanted to ask her questions, but did not want to ruin the moment by sticking his foot in his mouth. She asked him about his family, about New York—the people, the food, the city. He tried to sound expert and authoritative, kept himself from saying too much. Then they were on Nanjing Road, surrounded by the stores, the signs, the neon bustle and glow.

"This is my favorite coffee shop," she said as they walked past one storefront, "and I love the shoes here, though I can't really afford them." Then she said, "Let's stop for a minute."

"I have to get in," he said. "Lunch shift starts soon."

"Oh, you'll be fine," she said as they stepped off to the side and out of the milling crowd. She lit a cigarette and offered him one, but Tony shook his head.

"Tell your boyfriend to buy some shoes for you," he said without thinking, regretting it as soon as the words had left his mouth.

She looked at him with a derisive grin and blew a cloud of smoke over his head. "My boyfriend? Hah! I don't have a boyfriend." She looked away and muttered to herself. Then she said, "You'd make a better boyfriend, I think."

"Maybe," Tony said. He could feel the sweat beading on his forehead and sliding down his back now, and when she was looking off to the side he wiped his hand across his brow and upper lip. They were still several stores down from the restaurant, and he was convinced of all the signs: she had held his hand the whole time, had told him how good he looked, had shown so much interest in his life. She had no boyfriend, and that smile— always that warm inviting smile.

"You see the restaurant? It's down there, on the right. I'd walk with you, but I don't want your uncle to see me."

"Sure," he said, his heart beating faster, his breath thinning as he stared at her face. For an instant, he thought of Master Zhu and what he had said about his drawing of Min, how it lacked energy and did not show her true beauty; and so now he wanted to taste what he thought made her beautiful, so he could show and maybe know her true spirit and color and life.

She was not wearing heels, so they were almost the same height, and when she looked back at him he stepped in and pulled her close in one motion, one hand holding hers, the other on the small of her back. He tilted his face and leaned in and closed his eyes as he had seen movie stars and all the couples in his high school do over and over a million times; had never kissed a girl before, but he thought he was doing it right, his life frozen, waiting for the touch of her lips.

Then he felt her slip from his grip. He opened his eyes, and she was still there but standing a few paces back, her smile dashed, eyes wide and blinking as if she were about to cry.

"I...I'm sorry," he said as he looked down, could feel that wormy warmth in his stomach churning up in his throat like a pool of waste and bile.

"No, no," she said. "It's my fault. I shouldn't...I just...*I'm* sorry. I didn't mean to give you the wrong idea."

You did, he thought, but he was already blaming himself more for thinking that a girl like Min could ever be attracted to someone like him. Then she was standing close to him again. "Listen," she said. "I'm older than you, that's all. If I was a couple years younger..."

"You don't have to do that, okay? I'm not some stupid little kid."

To his surprise, she pushed his chin up with one finger so she could look him in the eye. "Listen, you're like a little brother to me! But more than that, you know? I mean, we're friends, right? Tony from America? Are we still friends?"

He felt himself wanting to smile even though he could not look at her. Then he nodded, and she said, "Trust me, there are going to be plenty of girls waiting to be your girlfriend down the road. And they're going to be very lucky."

He knew she was patronizing him, but he didn't have the energy to speak up and defend himself anymore. He looked at his watch and said, "I should go." She nodded, and he walked to the restaurant taking deep breaths, his head and chest clouded. He thought he could feel Min watching him from behind, so he did his best to hold his head up and throw his shoulders back as if he were impenetrable, invincible, as if nothing in the world could hurt him.

By the time he got to the restaurant, the lunch shift was in full swing. His uncle saw him and followed him into the back room, threw an apron and white shirt in his face.

"I got lost," Tony said. "I'm sorry."

"Of course you did," his uncle said. He turned and marched back into the dining room, and Tony knew that after work he would be lectured yet again. He picked up his usual section of tables, scooping and gathering dirty plates and glasses into his tub at a frantic pace, wondering if what Min said was true, or if it was all part of the same speech she had given countless times before.

He saw Master Zhu a few days later. They took a cab to a museum, Master Zhu's idea.

"It will do you good to see the range of Chinese art. Only then can you truly begin to create your own." As they walked into the museum, Master Zhu said, "They are building a new museum in the People's Park, not far from here. Very big, very modern. It won't be open for another few years, but it will be exciting."

"You sound like my uncle," Tony said.

"Unlike your uncle, I just hope I am around to see it."

Inside the museum, they seemed to glide from hall to hall. They saw pots and vases and bowls, ancient artifacts retrieved and excavated by archaeological digs—pieces of murals removed from tombs, statues, figurines, detailed scenes carved into stone. There were hanging scrolls and paintings of mountains, rivers and trees, fluttering birds and butterflies, glowing flowers and bubbly fish; women dressed in fine robes dancing, children playing, men in armor with swords and bows riding horses off to battle. Master Zhu explained how these paintings spanned the centuries, reflecting the emperors and dynasties and changing periods of China's history. Some were in color, others done with black ink on faded yellow-gray paper or silk, and Tony thought it was a miracle that these paintings had survived so many hundreds of years.

They walked slowly, contemplating, Master Zhu talking, explaining.

"There are two main styles," Master Zhu said, "fine-line and freehand. See how these paintings depict each scene exactly how it was? Fine-line. That was the predominant style back then. The goal was to create a scene as clearly and as accurately as possible. But you see these paintings? They use a more visionary approach, playing with shapes and sizes and illusion—that's freehand. Do you know what kind of style I use?"

"Freehand."

"Yes, that's right."

"I've been looking at the catalogues you gave me."

Master Zhu smiled and said, "That's good, but it's not enough to look at paintings in books. When you go back to New York, you must go to the museums. You will see amazing things. Then you will feel bad that you haven't taken the time to appreciate them."

They kept walking. Master Zhu went on.

"I remember seeing my first Picasso. I was in New York with friends, and they took me to a museum. I stood in front of it, just staring, admiring. I can't even remember exactly which painting it was. But until then I had only seen his work in books. It was so much more beautiful in person than

I could have imagined." Master Zhu laughed a little, his smile spreading across his face. "I must have stood there for five, ten minutes. Maybe longer, I don't know. But eventually my friends told me there were four rooms of Picassos to see. Silly bumpkin I was, I'd thought this was the only one!"

Then Master Zhu asked, "Have you been practicing?"

"I've been trying."

"Your uncle bought you the materials?"

"Yes, he did."

"Good. And what have you come up with?"

A pause, then Tony said, "Not much, I'm afraid." They stopped in front of a huge horizontal scroll on old yellow paper, with dragons flying, darting, wrestling among the clouds. "I practice lines and experiment with the brush," he said, "but what am I supposed to paint?"

As they moved on past the wide scroll, Tony saw Master Zhu's eyes pensively fixed to the ground. Then Master Zhu said, "Chinese painting used to have many rules. Only certain subjects were considered artistically and spiritually valuable: mountains and rivers, birds and flowers, bamboo and trees, vegetables and fruit. Back then, painting was supposed to serve the gods and Buddha, and the emperors. But even today, these subjects have special meanings. For instance, bamboo stands for uprightness and simplicity, something that is strong and not full of itself. An orchid stands for modesty, and a pine tree stands for steadfastness. Mountains and rivers and landscapes stand for tranquillity, or sadness, or just a sense of spirit and higher presence. It's part of tradition to paint classical subjects. It's also a challenge for each artist to depict that subject with his own vision and creativity."

"Like your paintings," Tony said. "They are very colorful. More than the paintings here."

"You are developing an eye. This is good."

They came to a bench and sat. Master Zhu said, "Painters today paint what they want. It is much more free, more exciting."

"How did you start painting?" Tony asked.

"My goodness, you are going to force me to go back that far?" They both laughed. Master Zhu sat thinking for a few moments. Then he said, "I was very young, only seven or eight years old. We had money, so my family was able to send me to school and hire a tutor to help me. When I got older, in my twenties, I started teaching at Shanghai Fine Arts Academy. Then I went to Japan to study. That's where I discovered all the Western painters that I love. After all those years of classical Chinese training, it was amazing to see what they were doing on the other side of the world, the freedom and vision they had, the technique and brushwork with oils and canvas. And how they used color—so vibrant, so daring. I was really struck by them. It changed the way I looked at everything. I think that influence has always stayed with me."

They stood and started walking again. Later, they passed through a hall of more contemporary paintings—one of an eagle perched on the ridge of a mountain, the eagle's eye and beak and talons clearly drawn, but the body just a blob and blur of ink; then a landscape with bright burning trees; then a painting of tree branches like a tangle of thick black and Technicolor vines.

Master Zhu asked, "Do you see the red stamps and the inscriptions on all the paintings? Those inscriptions can be poems—either famous poems, or poems written by the artist himself. Some inscriptions are just phrases, notes that are meaningful to the painting, the painter, the inspiration of the scene. Some include dedications to friends and teachers. Some long, some short. The red stamps are seals. They are almost a separate art form altogether. It is usually the stamp of the artist's name or studio, or sometimes a certain phrase or motto that belongs to the artist. The seals show ownership, and on some old paintings, you'll see many stamps that show all the previous owners a painting might have had. So the inscription and the seal help create a kind of history to the painting for any viewer to see.

"When you paint your first masterpiece, I will write for you an inscription and carve for you a seal. Does that sound like a fair deal?"

"It does," Tony said.

It took them over two hours to walk through only half of the museum. But Master Zhu was looking tired, his face haggard, eyes watery, so they decided to head back. Outside the museum, Tony flagged down a cab. In the car, Master Zhu sat back, looking more relaxed and comfortable.

Tony said, "I'm just having a problem figuring out what I'm supposed to paint."

"Paint what is clearest in your mind and strongest in your heart. Remember: To paint something new, you must try to forget that the subject ever existed. Whether it is a person or an object or a place, you must erase it from your mind and create it fresh and new."

As they pulled up in front of Master Zhu's gate, Tony reached into his pocket to pay the cab driver, but Master Zhu gently slapped his hand away and paid, then stepped out of the car. On the sidewalk, Tony pushed his elbow out for Master Zhu to grab onto his arm. Then he looked over and saw Master Zhu leaning back as if teetering on an invisible wire, his eyes half-open, the tip of his cane hovering over the ground. Tony lunged, took two quick steps, and caught Master Zhu from behind. As he held Master Zhu, his body limp, sagging in his arms, he saw Mrs. Zhu opening the front door and running down the walk-way, the sound of her pitter-pattering slippers against the concrete filling the air.

CHAPTER 13

He told his uncle what happened, and his uncle asked him over and over again. "He just fainted? Are you sure that's it? There's nothing else you need to tell me?"

"No," Tony said.

"You're sure? You didn't make him eat or drink something funny?"

"No."

He was sitting in his uncle's office at the restaurant, his uncle staring blankly at the security monitors and all the workers scrambling about.

"I'll call him," his uncle said. "You're sure there's nothing else?"

Two days later, he went with his uncle to see Master Zhu. They brought boxes of food and pastries from the restaurant and two bottles of wine, and gave it all to Mrs. Zhu. Tony was surprised when she led them up to the studio. They found Master Zhu behind his painting table, brush in hand. He looked up and welcomed them in.

"It was nothing," Master Zhu said. "I got lightheaded, a little tired. Too excited talking about painting with my friend here." He poked Tony's leg.

"Please, do not feel obligated," his uncle said. "Your health comes first, Master Zhu."

Tony nodded in agreement. He did not want to see Master Zhu fall or become sick again.

"Nonsense," said Master Zhu. Then he turned to Tony. "Have you been practicing?"

"I have."

"I'm in trouble with my wife right now, but give me a few more days. When you come back, I want you to show me two paintings you've worked on. Remember our agreement: For your masterpiece, I will write a poem and make a seal."

When they went back to the restaurant they prepared for the dinner rush, as Tony refilled his station with chopsticks and serving spoons, plates and bowls, cups and glasses. Then he helped Min set all of her tables, tried not to look at her too much, did not want her to feel weird around him, make things more awkward than they already were. Maybe a joke, he thought, might break the ice; or maybe keep his mouth shut and pretend nothing had happened (as she seemed to be doing), and if there was a reconciliation to be made, let her initiate it. But as the night progressed there was no time to be indignant, as the tables kept filling and refilling, and he and Min worked nonstop and smoothly together to keep it all under control. A few times when they crossed paths she smiled at him or patted him on the arm to show her appreciation. Of course, he still thought her beautiful and wished she would adore him as much as he adored her; but he began to think there were worse things than being considered a little brother or friend.

As the evening wound down he helped her serve their last big table, and on his way back to the prep area, she said, "Nice job, Tony from America. You might have a future in this industry."

"I hope not," he said. She scrunched up her face and shook her head, both of them laughing, and he knew things between them were okay.

At the end of the night he finished clearing and wiping down all the

tables, threw his dirty whites in the big hamper, then changed into his good sneakers. The dining room was empty now, only the cashier still counting out the register, a few waiters and waitresses trading good-byes. He saw his uncle come in through the front door, a scowl on his face, running his hand through his hair from front to back.

"Where are you going?"

"Nowhere," Tony said.

"We're leaving once she's done." He gave the girl behind the counter a stern look, then his uncle disappeared through the swinging doors and into the back. Tony stepped out front and saw Min standing alone, staring into the sky.

"What's up?"

"Oh, it's you," she said, startled. She tried to light her cigarette, but her hands were shaking.

"Maybe it's a sign," he said. "You shouldn't smoke so much. It's bad for you."

"Bad for me," she said. "Right. Like so many things."

There was something icy about her now, a distance that was palpable even though he was standing right next to her. He thought they had gotten over it, that things were once again balanced in the universe, but apparently they were not.

He took a deep breath and said, "Min, I just want you to know, I really am sorry."

She turned her head and looked at him as if he were a stranger, as if she had not even seen him standing there. "Sorry about what?"

"You know...what happened."

She lit her cigarette and took a deep drag, shook her head and smiled. "Oh, that. Let's not apologize anymore, okay?"

"Okay," he said. "I just thought you were still mad, that's all."

"Mad at you? I don't think I could be mad at you if I wanted to." A pause, then she said, "I wish all my problems were so simple." She put

out her smoke, looked at her watch. Then she took his face in both hands and smiled. "Thanks for looking out for me, Tony from America."

He got into the habit of practicing early in the morning and late at night before sleep. His uncle didn't seem to mind how long he stayed up; he knew his uncle would be at his bedside nudging and shaking him first thing in the morning, no excuses.

He was good at making the ink now, and getting better with the brush. He had asked his uncle to buy him more paper, having gone through so many sheets just working with lines and nuances of the brush—holding his wrist steady, moving his entire body, drawing a complete line in one breath to maintain a solid flow. He experimented with the pressure and angles and speed of the brush head, the slightest adjustment or change made an immediate difference, and he remembered playing with paint-can nozzles, molding and twisting them with pins and lighters, shaping them to his needs. The paint brush was different in shape and form, but not so much in theory.

First he tried to paint Min as he had seen her the night before—her dark hair and brooding eyes, her long legs and the red dress she wore in which he thought she looked so beautiful. But when it came to rest of her face he began to lose the image. He pressed on, added more shape, more detail. Soon he thought the portrait looked more like Maria than Min, but it was neither, and he felt like he was painting a stranger or a shadow, smudged and unclear. He remembered what Master Zhu had told him: Paint what's strongest in your mind.…To create something new, you must paint it as if it has never existed before. He thought about Master Zhu's landscape paintings and what he had said about a mountain, how it could be painted a million times and never look quite the same. And he realized what was strongest in his mind was his old neighborhood, the buildings and streets and the curling metal mass of the expressway right outside his window. Even on a busy day, surrounded by the raucous squall of his Shanghai life, he would find himself mixing images of what he felt and

missed and knew most into the surroundings he found here.

He began painting a place very far away, a kind of past life, and yet it was vivid and clear. The thought that he would soon be returning to it made him both happy and sad. Like this, he painted until his eyes began to close.

He went back to see Master Zhu and brought with him the two paintings he had done.

"They're not finished," Tony said.

"They're never finished," said Master Zhu. He laid the paintings flat on the table and stood over them, staring. Tony wondered what Master Zhu was thinking, a nervous squirm in his stomach, his arms folded in front of him.

Then Master Zhu said, "This one." He pointed at the painting of the mystery girl that Tony had pushed on with and tried to finish. "Not so good," said Master Zhu. "The lines are weak, uneven, like you are painting with only half your heart. The background is cluttered, messy. No sense of balance, or peace. The girl's face is cloudy, like a ghost. Is that the effect you were going for?"

"No, it wasn't."

Master Zhu turned his attention to the other painting, the one of the old neighborhood as Tony could remember it: spiraling spears of towers and buildings, the twin snakes of the expressway and the subway line twisting into the horizon.

"Much better," said Master Zhu. "The lines are consistent, stronger bone structure. The buildings are separate but still look like one entity, like blades of grass grown together in a cluster. This bridge behind the buildings, I like the illusion winding through the background. You use space much better here. The guest-host balance is cleaner. Do you see all this?"

"I do," Tony said. "I knew the one of the girl was no good even while I was doing it."

Master Zhu looked at Tony and smiled. "An artist never knows if his work will speak to others, but you have to know when the work is vital to

you. That is the most important thing."

They sat down to eat the lunch that Tony had brought from the restaurant. Master Zhu's studio had become like a second home. He felt comfortable there in the cool shade and quiet, surrounded by books, by art, Master Zhu's strong yet serene presence. Tony ate slowly, listened to himself and Master Zhu chewing. Then Master Zhu said, "Are you upset that I criticized your work?"

"Not at all."

"Then why so sad?"

Tony gulped down a mouthful of food and put down his bowl and chopsticks.

"Well, I'm leaving soon."

"That's good, isn't it? Don't you miss home?"

"I do, I miss it very much." Tony paused, staring at this half-eaten food. He had that squirmy feeling in his stomach again, took a deep breath. "I was angry when my parents sent me here, but it's actually been good. Working at the restaurant isn't so great, but I did meet this girl."

"A girl?" Master Zhu's eyes widened as he smiled. "Now I understand the painting. The unknowable face of the muse..."

"No, that's not it," Tony said, laughing. "I like her, of course, but she...well, we're just friends. But she's upset about something, and I don't know how to ask her what's wrong. I'd like to help her, if I can, but I don't want to offend her."

"Sometimes all you can do is be kind and try to listen. But you can't make people talk when they don't want to talk, or change if they don't want to change."

"I guess you're right," Tony said. He sat quietly staring down at the floor, twiddling his fingers, sorting out what he was feeling, what he wanted to say. "But it's not just her, you know. I mean, I'm starting to feel like...like I belong here. And when I go home, it's going to be exactly how it was when I left: back to my parents, back to the restaurant, back to

school. Back home, I don't belong anywhere. No one listens. And I hate that. I'm sick of it.

"Here, I get to hang around with you. I mean, you actually *talk* to me like I'm a human being and not an idiot. And you teach me all this great stuff about painting."

"It's been my pleasure," said Master Zhu. "You keep me company and bring me lunch—who can ask for more?"

They finished eating as Tony wolfed down what was left in his bowl, surprised at how the conversation had turned, his throat growing tight, eyes getting hot. Then Master Zhu said, "Are your friends back home creative?"

"I don't *have* any friends back home."

"Well, that's not true."

"No, Master Zhu, you've never spent a day in my school before."

Master Zhu waved his hand, dismissing Tony's comments. He said, "Maybe that's part of the problem. You have to surround yourself with people who support you. The more energy and creativity you surround yourself with, the more you will push yourself to be better than you are today.

"I used to be part of a group called the Culture Club, right here in Shanghai. All artists who would come together and work on large paintings as a group—it was an exciting time, amazing really. We would talk, learn from each other, share ideas, commiserate. We put aside our egos for the sake of the piece at hand. It was always fun, inspirational.

"It's okay to feel lonely sometimes, to feel sad, or depressed, or angry. Life will never be a flat even road. You must learn to use adversity to your advantage. Adversity is good for an artist—it will make you stronger."

Master Zhu refilled his teacup, then sat back and sighed.

"Are you getting tired?" Tony asked. "I should leave so you can rest."

"No, I'm fine. I'm thinking, that's all." A long pause. Tony piled up the bowls and chopsticks and stuffed the empty cartons in the garbage. Master Zhu touched Tony's arm and told him to sit.

"Let me ask you something," said Master Zhu rubbing his beard

slowly. "To be honest, you seem to know very little about Chinese history or culture. It's really a shame. So I want tell you a story. Do you mind?"

Tony shook his head and eased back into his chair as Master Zhu began.

"Have you ever heard about the dynasties or emperors before? Emperors ruled China for centuries. They called them 'sons of heaven,' because only the emperor knew what the gods wanted for the people.

"I was just a little older than you when the Qing Dynasty fell, the last dynasty. The country was changing, modernizing. Then suddenly the emperor was overthrown, and the Republic of China was created. Imagine your life today, the leader of your country and all the laws of the land suddenly changed overnight. That's what it was like for us: the emperor was gone and Sun Yat-sen was our new president and leader. Then Sun Yat-sen died, and it started a civil war between the Communists and the Nationalists, Mao Zedong and Chiang Kai-shek both trying to take over.

"I was still a young man back then. Things changed so quickly, people came to power, then fell, and then they fought and fought for years. But even with all the turmoil, Shanghai kept on thriving. By the time I had come back from studying in Japan, Westerners had taken over big parts of the city—French, British, Americans. Even where I live now, was mostly German. What a frightening and incredible time."

There was a knock at the studio door. Mrs. Zhu's voice rang through, saying, "Is everything okay in there?"

Master Zhu said, "Fine, we're fine." He sipped his tea and took a breath. His eyes were glossy like shiny coals, as if peering into a looking glass. They listened to his wife's footsteps as she walked back down the hall.

His voice lower now as if to avoid his wife's detection, he said, "In the thirties, the Japanese invaded, scared almost all the Westerners back to their own countries. They destroyed so much of the city…it was a terrible time. So many innocent people died—the Japanese army killed so many people. All of this was before the big war that you probably know,

between Japan and Germany and Italy against Europe and America and the rest of the world.

"When it all ended, Shanghai did what everyone else in the world did. We rebuilt, moved on. That's what strong people do.

"As an artist, you strive to find a place in your life where you are not distracted or prevented from doing what you do, being who you are. No matter what the discord of the world, I did my work. Because that was all I could do, keep working, keep believing in myself.

"When the Japanese were finally defeated, the civil war between Mao Zedong and Chiang Kai-shek picked up again. Chiang and the Nationalists lost and went to Taiwan. That was 1949. We thought that would be the end of it. We were right for some time. Everyone was united, positive, moving forward." Master Zhu looked at Tony, who sat hunched with his elbows on his knees, his face resting in his hands.

"I'm boring you," said Master Zhu.

"No," Tony said, "I'm listening." The names and dates and who was fighting who was confusing, but he knew it was generous and kind for Master Zhu to take the time to talk to him like this, to explain. No one else ever had—not his parents or teachers. So Tony sat fixated, ready to soak up every last word.

Master Zhu went on. "I was almost seventy years old when it started. There were days I thought it would break me. I really did."

"When what started?" Tony asked.

"The Cultural Revolution," said Master Zhu, his voice now tired like a whisper. "You think things have hit the absolute bottom, that they can get no worse. And then they do."

CHAPTER 14

He told Tony the year was 1966, and how on that day, waiting in the small empty classroom, he remembered seeing his breath like a frosty mist hanging in the air. He was with his colleague, Wang Tin, and they were being guarded by two men who looked so young, smooth-faced and thin, just boys wearing armbands, with myriad buttons and pins in honor of Mao dotting their gray hats and jackets like shards of glass. Both of the guards were smoking. Wang Tin coughed and the guards told him to shut up. Zhu could hear the building din of the crowd just outside the window, but from against the far wall he could only see the bright light and blue sky of day.

The desks and chairs had been cleared away so that the room was just an empty box. It looked much smaller this way.

"Teacher Zhu," Wang Tin said, whispering, "if anything happens, I'll protect you."

"Don't worry about me," said Zhu. "Protect yourself."

There was a knock on the door. The guards put out their cigarettes, then grabbed Wang Tin and Zhu by the arm.

"Come on," said the one guard.

"You take it easy with Teacher Zhu," said Wang Tin. Zhu gave Wang Tin a look, a quick shake of the head.

"Shut your mouth, pig," said the guard.

They were marched down the hallway strewn with shredded paper and garbage. Red paint and mud smeared the walls and floors. It did not look like his school anymore, more like some shattered, wild wasteland. Posters and placards and paintings that once hung so dignified and beautiful were now smashed, gone. From a broken window he could see a small bonfire burning, thick trails of black smoke rising.

The guard's grip on his arm was tight but did not hurt him. He was being pulled at a quick pace, but Zhu kept up, did not want to create a problem. He knew Wang Tin was too tense, too protective for his own good. His student from years ago, and now his friend and a fellow teacher himself, Wang Tin kept looking back at Zhu even as the guards screamed at them to hurry.

At the end of the hall they slammed through a set of doors, then they were outside. The sting of cold air hit him first, then the roar of the crowd, a blanket of sound that buzzed like a force that might carry them away. There were so many people; thousands, Zhu thought, as they were led through the sea of faces, a path clearing in front of them. With each step it seemed the chanting and screams grew louder. He could not make out exactly what they were saying. A part of him was trying to block it out, trying to focus on the path in front of him so that he did not trip and fall and humiliate himself even more. There were signs and posters and flags flying, as if this were some kind of national holiday, and he realized that was exactly what it was for these people—something to celebrate, to rejoice in.

They all looked so young; he tried to recognize his students, but could not.

He took in the wreckage that had once been the campus of the art academy, and it did not fully surprise him. He had felt it, seen it coming. It had been brewing for some time now. He had heard about the uprisings and

unrest from other places like Beijing, millions of young men and women banded together as Red Guards, given the ordinance by Chairman Mao Zedong himself to fight against "the four olds": old ideas, old culture, old customs, old habits. The youth had license to denounce and persecute anyone or anything that they felt was a hindrance to the dawn of a new age, the revolutionary cause. They attacked schools and teachers, defaced temples and sacred sites, destroyed statues of the Buddha, beat monks who tried to stop them. He had even heard of children turning in their parents for being too strict or stern in their discipline, for believing in Confucian values. No matter the relationship, the revolution was to make all people equals under the skies of heaven. Down with yesterday—make way for a new tomorrow. No man or woman had the right to stand separate from the rest.

In recent weeks he had seen packs of students huddled together, whispering with shifting guarded eyes, had walked by classrooms and seen them painting giant posters and banners, heads bowed in concentration. The signs began to appear on campus, in hallways, plastered across open walls, criticizing the school's administration, its teachers. He had not tried to stop them, nor had he tried to fight or run or hide, for he knew these efforts would be useless. He was just one man; he felt small and weak, helpless like a pebble on a vast white beach, waiting for the great crash of the sea.

Now he and Wang Tin were shoved up the steps of a big platform, onto a stage in the center of the crowd. The university's square was filled with dark jackets and hats, pale faces and pumping fists, the noise so fierce, so loud. A young man walked onto the stage with them. He placed a big wood placard around each of their necks, then someone handed him a microphone. He looked at Zhu and Wang Tin, grinned, then turned to the crowd.

"These two enemies of the people," the young man said, "they are Zhu Qizhan and Zhang Wang Tin, and they are guilty of teaching bourgeois values to their students. They have attempted to suppress Mao Zedong Thought by perpetuating rightist and counterrevolutionary ideologies, by encouraging their students to embrace their individuality instead of the

masses and to adopt Western styles. Without shame they promote Western influences and ideas, for their goal is to create class conflict, to separate themselves from the people!"

A wave of shouting and boos washed over them. Wang Tin was staring down at his feet. Zhu could only see two or three rows deep into the crowd, but the faces all seemed to blur.

"Who will bear witness to the crimes of these two bourgeois pigs?"

Another young man walked onto the stage. He was skinny and wore glasses, shoulders sagging as he took the microphone. Zhu looked at him but did not recognize him. From the side of the stage the young man said, "I have had experiences with both Teacher Zhu and Teacher Zhang. Teacher Zhu often boasted of his experience in Western painting and made a mockery of Chinese painting. He is an elitist, a capitalist roader who believes in bourgeois ideals and keeping common people down. Teacher Zhang is also an arrogant elitist who promotes the use of Western technique and style and declares its superiority to classical Chinese painting. They are both enemies of the Great Chairman Mao and the Chinese people!"

It was as if the young man were speaking a different language; Zhu heard him, understood the words, but felt like he was floating outside himself, watching himself in an alternate universe. Of course he had spoken of Western style and technique—he was a teacher; it was for the benefit of his students, to train them, make them aware, help them grow. But he had never mocked or denigrated Chinese painting. Nor had Wang Tin. He had been a good student, and Zhu knew he was a good teacher, liked and respected. So what kind of circus or nightmare could this be?

Then Wang Tin raised his head. Staring at the young man he shouted, "You are an idiot and a liar!" Even without a microphone his voice was loud. There was a gasp in the crowd. Zhu thought Wang Tin might lunge forward to attack, but the guards had jumped on him, grabbed him. Wang Tin struggled, trying to pry free his arms, kicking his legs and thrashing his

head, but there were hands all over him, holding him down. Zhu watched him, tried to make eye contact, wanted to tell him to stop, just stop.

They twisted Wang Tin's arms behind his back, pulled his head back by a handful of hair. The young man with the microphone said, "You, Zhang Wang Tin, will be punished first!" The raging cheer of the crowd. Zhu was pushed to the side of the stage.

The guards kicked Wang Tin in the backs of his knees until he was kneeling, center-stage, his hair still being pulled. He had wavy hair that Zhu now remembered was always falling in his eyes. A guard was holding Wang Tin by the back of his neck with one hand, had hair clippers in the other. Wang Tin was shouting, still struggling. A guard kicked him in the stomach as the other guards pulled back on his arms while standing on the backs of his legs. Then the guard with the clippers ran them from the back of Wang Tin's head, up the middle, all the way to the front. Hair sprayed and fell in big tufts. The guard ran the clippers back and forth two, three, four, five more times. Wang Tin's head hung forward now. Had he lost consciousness? Zhu could not see his face. The guard with the microphone was shouting like a madman, cackling. They poured ink over Wang Tin's head, mixed it with the shorn hair into a kind of muddy glue. Zhu could see Wang Tin fighting to keep his eyes and mouth pinched shut as the guards worked the ink with their fingers up into Wang Tin's nose and ears until he opened his mouth. Then they splattered it over his lips onto his teeth and tongue, rubbed it hard and fast into his eyes. Wang Tin screamed. They punched him and kicked him, the blows raining down.

How long this went on for he was not sure. As Zhu watched them beat Wang Tin, everything around him seemed to fall away except for the image of Wang Tin's black-smeared face streaked with ink and blood like a ghoul. Then Wang Tin slumped over and they let him fall, dragged him off-stage. There was more chanting, more shouting. The guards with their red-and-black hands turned to Zhu, who knew he could not run, could not fight back. He took a deep strong breath and looked at the guards as they

approached. Then the guard with the microphone said, "Wait. Stop."

Everyone turned to look at him, waiting for his order.

"Leave him be. He's just an old man." The guard with the microphone sighed, then said in a slow clear voice so all the crowd could hear: "We are not animals. We do not want the people to think we are unusually cruel."

At home, he was confined to the second floor of his house. The first floor was taken over by a group of Red Guards who used it as a kind of home base for operations. They were dirty and loud, like a pack of animals running roughshod through a barn. Yet Zhu felt fortunate that his studio was on the second floor. He spent as much time there as possible, even though his work was now dictated, monitored. He was only allowed to paint replicas of classical Chinese paintings deemed acceptable to the revolutionary cause. No more of his own work, nothing new. Most of his paintings had been confiscated, some of his favorites torn from the walls, smashed and burned before his eyes. Others still hung, slashed and broken in their frames. It wrung his heart to see this, but he knew it was for the best, that the work was a kind of sacrifice. He tried to look at what was happening to him, to all of them, as yet another test. At least they had not stopped him from painting altogether, had not taken a match to his home or studio as they had done to others. He found solace in this.

When he was not at home, he was made to work in the streets. They gave him a broom and a pan, made him wear a placard that had his name and crime written upon it:

"Zhu Qizhan, Reactionary Bourgeois Artist." His job was to sweep a small area at an intersection close to his house. He could feel himself being watched by Red Guards, by strangers passing by—who could tell these days who was friend and who was foe? He kept his head down, his broom moving. Even if there was nothing to sweep, he swept the dust and tried to remember all the places he had seen traveling through the years, the vast and beautiful stretches of China's countryside, the mountains and rivers,

valleys and sunsets, lakes and trees, the soothing calm of a morning mist. The memories gave him strength. He told himself there was more to do, more to see. He swept each day until someone told him it was okay to go.

They made him write page after page of self-criticism, admitting to his crimes against the people and the state.

"I, Zhu Qizhan, am guilty of teaching bourgeois and counterrevolutionary lessons to my students at the Shanghai Art Academy. By encouraging their expression of individuality, I taught my students to separate themselves from the masses and to pursue selfish goals. By shamelessly preaching the use of Western technique and style, I tried to lead my students down the capitalist road."

He believed none of it, wrote it only because he knew he had to. In these confessions he never referred to his friends, other painters, knew that even the slightest mention of another might lead to their own misery and demise. He found different ways of writing the same thing, traced his life backward to find crimes to which he could admit—his days as a young boy from a merchant family, being educated by a tutor; his early visits to Japan to learn oil painting; and then later, how he used to own part of a soy sauce factory. He knew that if he did not confess, these things would be discovered regardless. Then he would be punished much worse.

As a part of his thought training, he studied the writings of Chairman Mao.

Revolutionary war is an antitoxin which not only eliminates the enemy's poison but also purges us of our own filth.

Our duty is to hold ourselves responsible to the people... Wherever there is struggle there is sacrifice, and death is a common occurrence.

We must affirm anew the discipline of the Party, namely:

1) The individual is subordinate to the organization.

2) The minority is subordinate to the majority.

3) The lower level is subordinate to the higher level.

4) The entire membership is subordinate to the Central Committee.

Whoever violates these articles of discipline disrupts Party unity.

There is in fact no such thing as art for art's sake, art that stands above classes, art that is detached from or independent of politics. Proletarian literature and art are part of the whole proletarian revolutionary cause; they are, as Lenin said, cogs and wheels in the whole revolutionary machine.

He studied, recited, memorized, but did not truly believe.

One day while sweeping, he felt the joints in his hands and arms lock up, freeze. He could no longer grip the handle of the broom, felt a pain like bolts of electricity surging from his fingers, up his arms and into his shoulders and neck, then down his back and knees. Was he having a seizure or some kind of attack? His brain felt numb, cold. He stopped even though he knew it was risky. A guard could be watching, could report him, or come over and berate him, even strike him. But he could not hold the broom anymore. He put his hands on his knees, bent over, and tried to breathe. Then he was sitting in the street.

He felt a hand on his shoulder and struggled to stand, the bones in his hips and back crackling. He turned his head to look up, saw a man with a furrowed forehead, big wet eyes and a mustache, an ashy pallor to his cheeks.

"Teacher Zhu," the man said, "give me the broom." He hooked his arm under Zhu's to help him stand. His touch was unthreatening.

"No, thank you," Zhu said. The man was taller than him, chubby in the face and around the waist, in his thirties or forties at least. Zhu said, "I'm sorry, I don't recognize you. Do I know you?"

"I was your student years ago, at the art academy. Teacher, please, let me. You shouldn't be doing this."

"Keep your voice down," Zhu said. "Someone might hear you."

"I don't care," the man said. "It's wrong what they're doing to you."

He did not give the man the broom, and after another minute of quiet quarreling the man walked away, bowing, shaking Zhu's hand, thanking him, though Zhu had done nothing except refuse him. He wished he could

have remembered the man as a student in his class, what he might have taught him, a more personal or intimate interaction, but he knew that this moment on this day would be memory enough.

The days and weeks and months went on. At times he wondered why he continued to sweep, to write these treatises of guilt that he knew were untrue. Had the world gone mad? Perhaps, he thought. And maybe a world such as this was not one he needed to be a part of. He had a family, he had lived a long life, seen many places, done many things. He felt like a puppet, a toy, an empty husk burned black doing the things he did now. He could lie down in the street, broom and pan in hand, and be struck down by the guards watching him. Let them take me, become another sacrifice to this revolution. Would there not be more honor in dying with dignity, than living in hopeless, endless shame?

Then he thought of his family: his wife, his children, his grandchildren. He remembered the sensuous epic scenes he had seen with his own eyes and then painted, the people he had taught, the moment of recognition in a student's eyes when the life of a new vision or idea is born. He thought of places around the world he had yet to see: England, France, America, horizons of the world still waiting for him. He had grandchildren to play with and watch grow, and he made a promise to himself that he would do what was necessary to see those days come true.

He attended more struggle sessions in the university square. He was used to this by now. They hung the placard around his neck, and sometimes he wore a big paper dunce cap on his head: always the same chants, same signs, little red books being waved, the same pictures and portraits of Mao. And what was the result of this revolution? Where was the change? He did not know. They made him stand on stage and bow his head. They did not make him do the airplane as they did to others, did not strap a plank of wood across his shoulders and arms and make him kneel and swing and wave like some crucified fool; because he never fought back or caused trouble, or because he was too old, or because he had never truly

committed any crime they thought worth vehemently punishing. Still, students he had never seen or did not remember stood before him and denounced him, and he thought of Wang Tin, how he had not seen his old student and colleague since that awful day, could still recall his ink-smeared visage and limp body being dragged offstage.

Then one day in the street while sweeping, he felt a hand on his arm. He stopped and turned and saw a young woman's round sad face. She had tears in her eyes, her lower lip quivering. He remembered her, or at least he thought he did. A former student? The child of a neighbor? Before he could ask, she said, "Teacher Zhu, I'm sorry."

"Sorry for what?"

"Teacher Zhang. He's dead."

"What?"

"He's dead." The girl wiped her eyes and nose with the cuff of her coat sleeve. "He fell out of a window. They say he fell…"

"'They'? Who is they? He fell where?"

Before he could ask another question, she turned and walked away, her head bowed, shoulders heaving. He knew she was still sobbing even though he could only see her from behind.

CHAPTER 15

"He didn't fall," Master Zhu told Tony. "He was pushed. Later we heard the same story over and over: people tortured to the point that they would go insane; then they would crawl or be pushed or thrown out a window. The guards would say they jumped, but everyone knew the truth."

Tony waited for Master Zhu to say more, but he did not. They sat for a long time, until Mrs. Zhu came into the studio with a new glass of water for Tony and a fresh-brewed pot of tea for her husband. She said to Tony, "It's getting late. Should we call your uncle?"

"Um, yes. I guess so." Out the window he saw it was nearly dark; the dinner shift had already begun. His uncle was really going to have it out for him, he thought. There was nothing he could do about it now.

"I'll call him," said Mrs. Zhu. "You stay here." She looked at Master Zhu, gave him a quick worried glance before quietly shutting the door behind her. Master Zhu did not look up, kept sipping his tea, that faraway stare stuck in his eyes.

He did not like seeing Master Zhu like this, lost in his memories, reliving moments of a terrible past. He wanted to say he was sorry, that he felt bad, try to share or at least understand some of his pain. But he knew

such a sentiment might come across as disingenuous, so Tony sat there, silently nodding, until he said, "So how did it stop? How did it end?" It was all he could think to say that did not sound stupid or out of place.

Master Zhu rested his teacup on the table. "They let me stay home because I was too old to sweep or do real labor. My job was to paint the classic paintings, to reeducate myself that way. That's when things started to get really out of hand. All over the country, Red Guard factions were becoming so big, but no one was controlling them—not the police or the government. So the Red Guards began to fight each other, trying to take over, tearing whole cities apart. It got to the point that the army was called in to take back control in some places."

"But what was the point?" Tony asked. "To just mess things up?"

Master Zhu sipped his tea, played with his beard. He looked at Tony and said, "I've asked myself many times: What good came of it? Why did it happen? To be honest, I don't know. I think people were confused back then. They were willing to believe anything, do anything, but it ended up being…a mistake. All the chaos stopped when Mao Zedong died. By then, it had been going on for ten years. So many people died. Thousands upon thousands. No one knows for sure."

Tony watched Master Zhu, saw his face hanging, hand trembling as he reached for his teacup. He tried to picture Master Zhu in the midst of all he had just described. It made him sad and angry; he could not see such a kind man involved in such things, being treated in such ways.

"But it's ironic," Master Zhu said. "As an artist, that period might have ended up being the best thing for me."

Tony shook his head, incredulous. "Master Zhu, how can that be *possible*?"

"It's true—painting the classics forced me to focus on my brushwork, and reacquainted me with the old masters. Since I was a young man, I'd spent so many years struggling to be unique and different, striving to find a new way of doing things. Then, all of a sudden, it was as if all my life's

work had been taken away. For years it was a black time, a sad time. I can say so now.

"But when I was allowed to paint what I wanted once again, I felt like I had been reborn with new vision, like a million chains and blindfolds had been removed from my hands and eyes. I thought, what else could happen? I felt so free because I knew I could survive anything. I had already seen the worst."

Master Zhu was half-smiling again, no longer seemed sad or dazed. "I'm sorry I've kept you so long," he said. "I'll call your uncle later, make sure you don't get in trouble. I want you to keep working on that painting of the buildings and bridges. I like where it's going. I will write you a poem when it's done, and paint the inscription.

"Okay," Tony said. He stood and shook Master Zhu's hand. "Thank you, Master Zhu, for sharing your stories with me."

And Master Zhu said, "Thank you for listening."

There were only two weeks left before he was supposed to go back to New York. He spoke to his parents briefly on the phone: his mother was excited to have him come home, while his father was reticent and short, as usual, telling him to finish up his time in Shanghai in a good strong way. When he got home, his father said, they could all work on a fresh start.

But Tony wondered, Would it really be a fresh start? Could it ever be?

He felt different now than he did at the beginning of the summer. He thought he had grown taller by maybe an inch or two, and had definitely lost weight. When he pinched himself, there was less to pinch. His pants now pulled loosely around his waist; his sagging double chin had melted away, and his stomach no longer hung over his belt. He could see the shape of his arms, the first real lines of definition in his biceps and shoulders, could do more than thirty push-ups and forty sit-ups in one set. Each morning, he jogged around the complex without stopping to gasp for air, and he felt like people didn't stare at him so much anymore, felt like he was

a natural part of the rush and zoom of the city.

At the restaurant, his uncle more or less left him alone. Tony knew what to do and he did it. He made no more big mistakes, had no more accidents, and the waiters and waitresses were all nice to him. One of the cooks actually came up to him and asked, "What happened to our 'fat dumpling'? You're just a regular dumpling now. We couldn't even serve you on a plate if we wanted to." He smiled and tried to pinch Tony's side, but Tony slapped his hand away playfully and the cook went back into the kitchen. Later, Tony thought of the pizza guy back home who called him "gordito," wondered if the pizza guy would change his nickname for him as well.

In the mornings and evenings he continued to paint, kept working on the balance of his strokes, the consistency and expression of each line. He liked what he was working on, and even more important, Master Zhu liked it as well. It was almost finished, but he was not sure. How would he know? After every few strokes, he stepped back to stare. A few small details wound up taking over an hour, nothing like the way he used to spray paint back home, when he had to be fast or risk getting caught. He liked this far better, being able to take time to look and think and feel where the next stroke of the brush might go. Danger was not an element: this felt like work, like art, not a felony.

What the true graffiti artists used to do back then, yes, that was art. He knew that painting was a very real and important part of him, could feel it in his breath and spirit when he held the wet brush in his hand; but he realized now that all he had done before coming to Shanghai—the sketching and doodling and spray painting of walls, including the fiasco at school—was just a bridge that had taken him to this place and time where he was learning and doing things that were important and true. Like Master Zhu, he would train himself to focus and move forward and look ahead. Each night before sleep, he would stare at his painting of the city as if a new part of it might grow inside him overnight, ready to blossom in the morning anew.

At the restaurant, Min was friendly, but she did not call him outside to keep her company anymore. A few times he popped his head out to say hello, but she always seemed as if her mind were elsewhere, her eyes glazed, disconcerted as she slouched against the wall. She wore less makeup now, and her red dress was often wrinkled, even spotted with a few stains; and though her hair was still tied in a braid, it seemed frizzy and loose, as if it might unravel with the slightest shake of her head. She did not shine the way she had when Tony had first met her, and he did not want things to end like this, distant and strange, as if they had never really been friends at all. He remembered what Master Zhu had told him, that you could not make someone talk or change if they did not want to. Obviously, she didn't feel the need to talk to him, and there was nothing he could do about that. But he still wished she would, wished even more that he could help her, save her from whatever it was that was eating away at her inside.

Then she stopped showing up for work. He asked his uncle what had happened.

"Sick," his uncle said, but Tony knew better.

Maybe, he thought, she had finally landed a role in a movie or on a television show; or maybe she had quit because she was tired of being a waitress, all the long hard hours on her feet and taking his uncle's crap to boot; or maybe she had just disappeared, was finished with the traffic and noise and congestion of the big city, had gone home to wherever it was she was from. But her absence did not stop him from thinking about her. He walked by her favorite shoe store and coffee shop, hoping to spot her, thought how painful and wearisome and dreary his days in Shanghai would have been if he had never met her. Sometimes he caught himself wondering what might have happened if she had let him kiss her that lost and lazy afternoon. But for the most part he worried about her like a sister and missed her like a friend; wherever she was now, he just hoped she was okay and finding something close to happiness.

The week before he was supposed to leave, he was working the dinner shift, every section full and a line of people waiting outside. He was covering two sections because one of the other busboys had called in sick, could barely think as he dashed from table to station and back again. Only seven o'clock and already he was a starving, sweaty mess, but he was in a rhythm and felt good knowing that just a few weeks ago he never would have had the energy and endurance to handle two sections on such a busy night.

Around nine o'clock there was commotion by the front door, and Tony thought for a moment that someone had fallen. Was it a waiter, or a customer? As he made his way back to the station, he kept his eyes trained in that direction, and then he saw Min sliding her way past the front counter and into the restaurant foyer. He almost did not recognize her: she was wearing jeans and a big baggy T-shirt, her hair teased out, wild, like a cartoon character hit by lightning. Under the lights she looked pale and waifish, no makeup, her eyes too small, lips like thin lines, her body tiny and alone and standing out against the boisterous and well-dressed crowd. Then his uncle was coming through the swinging doors, wearing a suit and tie, shoes shined, and hair combed neatly as if ready for a night on the town, a smile on his lips as if he had been awaiting her arrival.

Tony was watching them but could not hear what they were saying over the laughter and chopsticks clicking and serving spoons clanking all around. His uncle took Min by the elbow and tried to lead her back outside, but she shrugged away and squared her stance to face him so that anyone watching would know she was going nowhere. His uncle dipped his head and crossed his arms and listened. A few times he lifted a finger and tried to interject, but Min was talking too fast, her eyes locked in on him, narrow like slits. It went on like this for over a minute. Then she suddenly covered her face with both hands and turned and bolted out the door.

The restaurant was so busy and loud that no one else seemed to notice, as if she had been nothing more than a dissatisfied customer whose complaint was being heard. Tony looked at his uncle standing in the foyer, one

ceiling light shining down on him like a halo. Lips pursed and eyes staring straight ahead, he was still nodding as if he did not know that the conversation had ended. Then he looked up and turned and went back through the swinging doors, and Tony felt a poke in the back, one of the waiters.

"Hey, c'mon. Still customers here."

"Right," Tony said. He picked up his tub and brought it over to his station, scanned the dining room floor to see if his uncle might reappear. Then he darted outside and into the street looking for Min.

He found her down the block, sitting in front of an abandoned storefront, with her knees folded up into her chest, her head down, sobbing. "Min," he said, and she looked up. He kneeled in front of her, wanted to hug and hold her to absorb her pain, but all he could say was, "Hey, what's wrong?"

She wiped her eyes and sniffled. He could feel people's eyes on them as they passed by, but he did not care.

"What happened?"

"Nothing," she said. "You should go back. You're going to get in trouble."

"I'm going back to New York next week," he said. "What's he going to do, fire me?"

She laughed for a moment, then turned away again, her eyes still red and teary.

"You make me laugh, Tony from America. Promise me you'll always be a good guy, okay?"

"What did he say? Did you quit?"

They were standing now, and she put her hands on his shoulders and said, "Don't ever pretend to be something you're not. Always be you. Don't be like...like *him*."

"Right," he said, even though he had no idea what she was talking about. "I will. Were you fired?"

"Yes," she said, "something like that." She put her hand on his left

cheek, leaned in and kissed him gently on the other side. "Good-bye, Tony from America."

He was startled by the kiss, though by now he knew better than to try anything funny. Nor did he want to—he just wanted to make sure she was okay. She smiled and turned and walked down the street, and did not look back; and Tony watched her until she had disappeared into the haze of the neon night, her shadow and stride lost in the eternal crowd.

That night they took a taxi home, and his uncle said nothing for the entire ride as he stared out the window. All Tony could think was that he would never see Min again, could not get her face out of his mind, kept feeling the soft touch of her hand and lips on his cheek. The heat in his stomach and lungs began to build as he imagined what it was that had transpired between her and his uncle and what they had said to each other.

Back in the apartment, his uncle took a long shower while Tony ate some leftovers in his room. He wanted to ask his uncle questions, figure out what the hell had happened, but he did not know what to say or how to begin, felt out of his league yet again, afraid of crossing so many invisible and unknown boundaries. Then he heard his uncle stomping and banging around outside, found him in the living room with a tall brownish-red bottle open on the table, a half-full glass in his hand. The television was on with no sound. The ashtray on the coffee table in front of him was smoldering and full. Tony sat on the far side of the couch, from where he could still smell the liquor.

His uncle looked at him and smiled. "You want some?"

"No thanks," Tony said.

His uncle's eyes were red, bleary. He gulped down what was left in his glass, then poured it full again. He had never seen his uncle like this before, had only seen the loud brash restaurant owner or the pious and humble man he was in the cemetery or in front of Master Zhu. He did not know what to make of this sloppy, drunk version of his uncle, the one who emp-

tied and refilled his glass two more times and continued to smoke and drop ashes on the floor as they watched the muted television. Soon it was as if Tony were not in the room at all, his uncle exploding in laughter and spitting on himself at random, his eyelids falling, head bobbing, words slurring as he mumbled under his breath.

"She's right…damn it…I'm…I'm…no…I'm a dog…no good…"

When his uncle's eyes finally closed and his snores were heavy and loud, Tony took the cigarette from between his uncle's fingers and stubbed it out in the ashtray. Disgusting, he thought. After two months in Shanghai, where everyone around him smoked like a chimney, he was so glad that his parents did not smoke, promised himself that he would never smoke. He slung his uncle's arm over his shoulders and lugged him into his room, kept his head turned to the side so as not to breathe his uncle's putrid breath. He let him flop down on the bed with a soft thump into his blankets.

"Good night, Uncle," he said, even though he knew he could not hear him.

In the morning there was a knock on the door. Tony thought it was his uncle calling him out to exercise. Impressive, he thought. Even after a night of drinking. Then he looked at the clock and saw that it was already seven o'clock; he got up and went outside, did not see his uncle. He heard the knocking again, realized it was coming from the front door.

He opened the door and saw an older man in a suit, tie, and glasses, standing with his hands clasped in front of him. He was not much taller than Tony, with salty white hair and many wrinkles, a cluster of moles dotting the side of his face. His round stomach pushed out the front of his suit jacket. A young man in a black uniform and hat stood behind him. The older man walked in past Tony, did not wait to be invited.

"Get him," he said to Tony. The man in the hat and black uniform stayed in the hallway. Tony closed the door, and the older man went into the living room and sat.

Tony went to his uncle's bedroom door and knocked. "Uncle, someone's here to see you." There was no answer, but he could hear rustling from behind the door. Then his uncle came out wearing pajama bottoms and a T-shirt. His hair was messed, his eyes red, the thick smell of alcohol and sweat coming off of him. "In the living room," Tony said. He watched his uncle walk into the living room but did not follow.

He heard his uncle say, "Mr. Chow, what a surprise. Um...can I get you some tea? Have you eaten this morning?" His uncle's voice was throaty, gravely. Then, as if he could sense Tony's presence, he said, "Give me and Mr. Chow some privacy, okay? Start getting ready for work."

Tony went in his room and closed the door, the latch clicking loudly. Then he slowly turned the knob and opened it just a crack so he could hear them.

"I got a call from the lawyer," the man said. "You told me this wasn't going to happen again."

"Sir, it's not as it seems. She's not telling the whole truth."

"The whole truth? I hope we don't have to go to court again to find out what *that* is."

The man's voice was low, growly. There was a long pause, and Tony could picture the man in the suit staring, his uncle fidgeting, trying to think of something to say.

"Sir, I don't think she'll do that."

"Well," the man said, "we'll see. But I've told you before—you keep sleeping with young girls, losing face for us, it will be trouble. The boss doesn't like this kind of thing. He wants smooth and steady. We don't need this kind of attention."

"I understand, sir."

"I hope so. One more time, you're through—no more company car, no more apartment. You'll be selling fried dumplings in the street, understand? Now clean yourself up. You look terrible."

He heard the man stand and walk out, his dress shoes clacking across the wood floors, then out the door. He heard his uncle say, "Thank you, sir. Thank you," but Tony wondered what thanks there was to give.

Later, on the bus to work, he and his uncle did not speak. He felt hot, each breath in his chest scalding, wanted to grab his uncle by his throat and shake him, ask him what he had done to Min and why; and who was that old man, and did he really have the power to take away his uncle's job and everything else? All this time he had thought the restaurant was his, that his uncle had owned it; and if he had lied about that, then what else had he lied about? Obviously he had lied about Min—all of that was clear now—but it was too much to deal with, and he knew he did not have the tools or experience to make full sense of the situation just yet. Maybe some other day, once he had returned to New York and gotten some perspective.

Then he was thinking of his parents, how hard they worked and how tight a ship they tried to run, appreciated the fact that there was never any question about who was who and who did what and why. Their world made sense because they played by the rules, and he could not wait to see them.

CHAPTER 16

The painting had been drying in his room for a day, and now he rolled it up and took it with him to Master Zhu's.

In the studio, they unrolled the painting and laid it flat across the big table. He stood next to Master Zhu, who hovered over one side of the painting, then slowly drifted across to the other side. Then he stood back and stared. Hanging close to his shoulder, Tony tried to see what Master Zhu was seeing, wondered what he was thinking. Finally, Tony asked him, "Do you think it's finished?"

Master Zhu turned to look at him, "You're asking me? It's your painting."

"I'm not sure."

A pause, then Master Zhu said. "You leave it with me, I'll take care of the rest."

They rolled up Tony's painting, and Master Zhu put it on the shelf behind him. Then he said, "I want to show you these." He grabbed two rolled-up paintings and spread them out next to each other. The one on the left was a landscape of green mountains, a thick mist fading the green rocks beyond into gray, two boats sailing like toys drifting toward the colossus of earth. The painting on the right, also a landscape, showed thick jagged

stones onshore blazing in gold, protecting a village nestled behind it. The peaks in the distance were huge and sprawling, sliced through by a snaking mist, a lone boatman on the sea floating away from home.

Master Zhu pointed at the painting with the green mountains and said, "I call this *A Lovely Day*. I finished it a few months ago. The other one I just finished recently. I'm going to call it *Good Mountain, Fine Day*." He looked at Tony and asked, "What do you think?"

"The one in green is more…peaceful," Tony said. Though his Chinese had improved a great deal since coming to Shanghai, he still took the time to recite in his head exactly what he wanted to say. He felt privileged to be shown Master Zhu's new work, and did not want to risk insulting him. "The gold one, is more…more wild. It has a different kind of energy. I like the color, and the mountains in the background are so big. They seem to hang over everything."

Master Zhu was staring at the paintings and nodding. He said, "I love landscapes. They're strong, but still delicate, beautiful. Powerful, yet nurturing. That's why the paintings are called 'mountain-water' paintings, because if you paint a mountain, you must also paint a river, or the sea. It is part of tradition, the balance of water and earth, yin and yang. I've done many landscapes in the past year. Maybe because I'm old, growing too nostalgic and wistful, but they make me feel good."

"I like how you use blank space," Tony said. "To bring out the mist and sky, and the ocean. It's all so natural. And it helps separate between the foreground and background."

Master Zhu's eyes widened as he smiled. "You've learned much, my young American friend. Your eye has gotten sharper, like your painting."

Both paintings were on square paper, maybe two feet by two feet, and Tony asked, "How long did it take you to paint these?"

"Some take only a few days. Others take much longer, many months possibly. But in each painting, I try to achieve four things: uniqueness, strength, simplicity, and spontaneity. By unique, I mean that a painter

should have his own features instead of depending too much on a set style. If you do that, it becomes style for style's sake and feels unnatural. Strength lies in a painter's bold and vigorous strokes, and simplicity means being concise. No wasted motion. Spontaneous means following my instinct instead of a specific plan. Every painting I do, I keep these goals in mind."

"So what's the hardest part?" Tony asked.

Master Zhu rubbed his beard, contemplating. "I think simplicity and spontaneity, because a painting must be done with proper technique and still be sincere and honest. With practice, you find that it is not so difficult to depict something with just a few strokes, but are you expressing yourself at the same time? This is the challenge—discovering something about yourself and your work. If you do not discover, then someone looking at your painting will not discover. A great painting will evoke feelings that can only be sensed, but not explained in words.

"I get this feeling when I know something is complete, but there is always the urge that I can or should do more. But even *that* feeling is always changing. For instance, your painting—do you feel it is done?"

Tony thought about this. "There's nothing else I can think of to add or change."

"Then it is finished. Now move on to your next piece."

Master Zhu looked at the clock on the wall. "I'm sorry we can't spend more time today. The doctor is coming over. When you are my age, there are always doctors waiting to poke and prod you." Tony helped Master Zhu stand. They went down the stairs together. At the front door, Master Zhu said, "You're leaving this weekend, yes?"

"Yes."

"Come back in a couple days. So we can have a proper good-bye. I will have a surprise for you."

The change at the restaurant was so slight, so subtle, that he was not sure if it was all simply in his head. During the day, setup and prep was the same—

the dumpling ladies, the cooks, the waiters and waitresses and busboys; the same routine, same chatter and conversation, same bickering and teasing as happened every day. But at lunchtime, Tony noticed that his uncle did not sit and eat with the staff anymore; at least he did not sit for the entire meal.

These days Tony sat with everyone at the big table, was allowed to have a taste of the fried dishes now that he had lost so much weight. It was nice being included in all the jokes and conversations, but still he tried to stick with his steamed chicken and vegetables and a bowl of white rice. It had taken him this far—he did not want to negate all the work he had done by getting lax in the end. Midway through lunch his uncle would drop his chopsticks, his bowl still half-full, and go upstairs; he would not be seen again until dinner, but even then his uncle did not roam the dining room chatting and laughing with patrons anymore.

Each morning now, Tony did his exercises alone. "You know what to do," his uncle said through his bedroom door. "Wake me when you get back." He went out into the courtyard and did his push-ups and sit-ups and stretches and bends. He ran around the complex, even added an extra lap to his regimen. He saw the same people every day: old people doing their own exercises and tai chi, young couples with their strollers and small children out for a walk. Tony waved and smiled to everyone, and no one asked where his uncle was, as if they had always been his friends alone.

He did not talk to his uncle about Min, and as each day passed the urge to do so dissipated. Instead, he played through in his mind all the different scenarios that could have happened between them: maybe his uncle had told her that he owned the restaurant and that he loved her, had promised her a wonderful life filled with escape and travel and riches; or maybe she had flirted with him, targeted him and led him on, tried to use his status and connections somehow to her own advantage. Maybe now she was seeking retaliation and retribution for being lied to; but Tony did not think she was a vindictive girl, one who would go to such measures to exact revenge. It was more likely that his uncle had done this one too many

times, a flawed man who liked women who were far too young for him, addicted to making promises that he could not keep.

Tony knew that the truth was probably somewhere in between, an amalgam of fact and fiction depending on which party you asked. He wanted to be angry with his uncle, but in the end he knew his uncle was his own man, as sure as Min was her own woman, both of them adults who had made their own decisions. They would have to deal with these repercussions; as surely as he would still have his own problems to face when he got home—Victor, his parents, school, it would all still be there, waiting. And when he thought about these "problems" and compared them to the hardships that Master Zhu had endured, he realized that life was not so bad, that it could always be worse if you allowed it to be.

At night after work he would find his uncle sitting in the living room, watching television or reading the paper, always smoking, always a bottle and glass on the table. These days his uncle did not look tired, did not seem particularly happy or sad. He just…was. And Tony remembered how after each long day his parents would fall asleep on the couch without fail, how much happier and more content they seemed in their exhaustion, always there to lean on each other night after night after night.

When he left for Master Zhu's apartment again, he carried with him a small wrapped package that his uncle had told him to bring as a gift, and of course, a few cartons of hot food. There was a tight squirmy feeling in his stomach. The end of August and still no break in the weather—it had rained earlier, making it muggy and sticky instead of cooling things down. Even this he had gotten used to, the city's blanket of heat. He was going home in two days. He walked slowly, taking in the passing houses and people and buildings and cars, thought that this would be the last time he would see these sights, at least for a while.

At Master Zhu's house, his wife led Tony into the living room instead of the studio. He thought this was odd. He found Master Zhu sitting on

the couch, leafing through the pages of a book, a cup and small pot of tea on the end table next to him. When he saw Tony, he patted the couch next to him for Tony to sit.

"What is on the menu for today?" Master Zhu asked.

"I'm not sure. My uncle packed it."

"And how is he?"

"He's…he's fine," Tony said. "Working hard as usual."

"Of course."

Tony could hear Mrs. Zhu in the kitchen, preparing the meal. He said, "I don't think I've ever sat down here before."

"I needed to get out of the studio. You work too much, your brain starts to get numb. Best to get away when that happens. Let your mind unwind, recover. It is possible to overwork, don't forget that. The trick is being able to recognize when you really need a break, and when you are just looking for an excuse." Then he said, "Before she comes with the food, I want to show you these."

Tony helped Master Zhu up off the couch. They walked over to one of the paintings on the far wall. "These are some of my favorites. Before you go I am going to give you the information for friends of mine in New York. They own an art gallery. It would be good for you to talk to them, maybe visit with them once in a while. And you must go to the museums when you get home. Do you promise me that you'll go?"

"Yes, of course," Tony said.

They moved from painting to painting, Master Zhu commenting on each piece. There were long clean scrolls of calligraphy, then flowers and plants, food, birds and bamboo, landscapes, bowls of fruit, each piece marked by Master Zhu's signature raw sweeping strokes and bold blasting colors. There were early oil paintings and pencil drawings that he had an affinity for, that he had done way before Tony, or even Tony's parents, had been born. At the end of a wall they came to the final piece. Tony did not recognize it at first, the big buildings and blur of busy streets, the

curling expressway and subway line, the background of the city night dotted with faraway lights, all surrounded by a deep green-and-gold matting. There were new lines of calligraphy in the upper right corner, finished with a red stamped seal.

"What do you think?" asked Master Zhu.

Tony kept staring as he traced his finger over the glass. It was his painting, but it did not look like his, matted and framed so beautifully. After a few moments he said, "It looks like a real painting."

Master Zhu laughed. "Of course it's a real painting. Whether you realize it or not, what you've done is a kind of landscape. Rough and wild, and still there is a calm to your vision, a peaceful order."

"What does the calligraphy say?"

Master Zhu pointed and said, "'My home, in the mountain of glass and steel.' The red seal, I made it for you. It is your Chinese name. When you leave, you take it with you, so you can add it whenever you complete a new piece."

Tony looked at Master Zhu. He remembered seeing him for the first time in his studio, how small and unimposing he had seemed, the strange circumstances under which they had been forced together. Now he saw the same man but in a different light, how full and strong and kind he was, all the generosity he had shown him.

"I wanted to surprise you," said Master Zhu. "I thought you should see what your work would look like mounted. Oh, and another thing." He shuffled over to the end table and picked up a thin black folder from which he pulled a small square painting. In the background were thick and bright streaking beams of color, the rainbow buildings that lit the Shanghai sky like fluorescent bamboo stalks. In the foreground on a narrow street, tiny and obscure, walked two figures, one with a cane.

"That's us," Tony said, and Master Zhu nodded.

"I'm sorry I didn't have time to frame it. I did it rather quickly, but I felt the inspiration."

Tony bowed his head slightly and shook Master Zhu's hand. He felt a ball growing in his throat but choked it back.

"Thank you, Master Zhu." A pause, then he said, "I'll be back to come see you. Soon I hope, with my parents next time. Or if you come to New York, you can come visit us. We'll go to the museums."

"It would be hard for me to travel these days, but you never know. Now come on, take your painting off the wall. Don't make an old man lift things."

"Thank you, Master Zhu. When I get home, I'll..."

"You will keep working, and getting better. Remember: you paint because you have to paint. No one in life will ever force you to paint or draw, or make music, or write. There is too much of it already in the world. So do what you do for the joy and satisfaction it brings you. Everything else will take care of itself."

"It's ready," said Mrs. Zhu. They could hear her behind them setting plates and bowls.

"Come on, let's go eat," said Master Zhu. "What will Mrs. Zhu and I do when you leave? We'll starve. We may actually have to go down to your uncle's restaurant for a meal."

"He would like that," Tony said. "I know he would."

His uncle had overslept and they were late. As they sped through the streets and down the highway, his uncle kept muttering and cursing under his breath, smoking, flicking ashes out the window, checking his watch. When they got to the airport, his uncle grabbed Tony's suitcase and ran through the parking lot and terminal, then barged his way into the middle of the check-in line.

"Have a great flight," said the smiling woman behind the desk as she took Tony's suitcase away.

They waited at the gate to check Tony's passport. The line was long but moving quickly. "Come on, come on..." His uncle kept looking at his watch, fidgeting, looking all around as if searching for a shortcut to suddenly appear.

"We're going to make it, Uncle. Take it easy."

"Easy for you to say. You miss this flight, *I'm* going to have to deal with your mother, not *you*."

"Want to get rid of me that badly?"

His uncle stopped fidgeting and looked Tony in the eye. "I don't want to get rid of you."

"I was just kidding, Uncle."

As the line began to move, his uncle made sure he had his passport, plane ticket, and other essentials for the long trip.

"Don't eat too much of that plane food," his uncle said. "It'll rot your guts out. And make sure you rinse after eating. Don't want your breath all stinky when you get off the plane and hug your mom...Do you have batteries for that game machine of yours? The gifts for your parents are in the suitcase, right? Your sketchbook is in your bag?"

"I've got it all, Uncle. Don't worry. I made it here. I'll make it back.'"

"You're awfully cocky," his uncle said, smiling. "Maybe your mom won't accuse me of ruining you after all."

As they got closer to the front of the line, his uncle said, "Remember when you first got here, we had a fight about your earnings?"

Tony looked at his uncle and nodded.

"Well, I didn't want to give you a big bag of money. So I wired it all back to your parents for safekeeping."

They were next in line. The airport agent was calling to them, waving them forward.

"It should take care of any of the problems you had last year," his uncle said, "and I included a little bonus, for good behavior." His uncle looked away, his eyes getting red. He looked back at Tony and said, "You're a good kid. I...I'm happy you came. You worked hard. Everyone at the restaurant liked you."

He pulled Tony into a hug, and Tony could smell the smoke and sweat in his uncle's shirt. Maybe he had made some mistakes in his life (who

hadn't?), but his uncle was still a good man who had kept his word: he had watched Tony's diet and trained him all summer, had taught him to push himself and really whipped him into shape. As he felt toward Master Zhu, he knew he owed his uncle for all he had done, knew there was only one way he could ever repay him.

Tony wiped his eyes with the palm of his hand. Then they stepped back, and the agent was calling to them again, louder this time.

"He's coming, okay?" his uncle shouted. He looked at Tony and said, "I'm proud of you."

"Thank you, Uncle. I'll write when I get back."

His uncle gave him a slap on the back and said, "Yes, I want you to send me letters and Chinese New Year cards. Tell your parents good things about me. Act like you really like me." He gave Tony a push toward the airport agent as Tony began walking toward the booth. His uncle shouted past him at the agent, "You idiot—don't you know it's rude to interrupt when people are saying good-bye?"

On the plane, he sat in the aisle seat next to an old Chinese woman who was crying. She wore a thick padded jacket, had short salt-and-pepper hair. She was alone, and her crying got worse when they took off. Tony gave her a tissue out of his backpack and asked if he could do anything for her. The old woman sniffled and looked at him with watery eyes.

"You think I'm a silly old lady for crying, don't you?"

"No," Tony said, "I don't."

"I'm going to see my new grandson in America. He's only a year old. I keep thinking, What if I die on the plane? What if something happens? I'm eighty-three years old."

"You're still young," Tony said, smiling.

The old woman smiled back. She said, "You're being fresh, teasing an old lady," but he knew she was not angry.

"Don't worry," Tony said. "New York is just like Shanghai."

"I've lived in Shanghai my whole life."

"Then I'm sure you'll be fine."

The old woman sighed, then blew her nose. The crying stopped. She patted Tony's arm. A stewardess gave the old woman an extra pillow, and soon she fell asleep.

Again he transferred in Hong Kong, and on his connecting flight he looked for the old woman, but she was nowhere to be seen. Then for the next twelve hours he napped, played his Gameboy, doodled in his sketch-book, leafed through the catalogues of Master Zhu's work. When the stew-ardesses spoke to him in English, Tony made a point of speaking back in Chinese. He felt like an old pro by now with this flying thing.

Just before landing, the man next to him went quiet, steepling his hands in front of his face, mumbling prayers to himself. After the plane came to a stop at the gate, Tony zipped up his backpack and filed out as quickly as he could.

Inside the terminal, he was struck by the raucous roar of the PA system, names and announcements being called out all around him. Like being dropped from one world directly into another, surrounded by white and black faces and a mix of everything in between. Voices in English and Spanish and other languages he did not recognize; he could read all the signs, and yet he felt strangely lost, off balance, like his feet and head were somehow gliding. He went through the sliding glass doors and into the luggage pickup area, was met by a larger rainbow-like crowd of hair and faces. Tony heard his father's voice calling his name, took a few seconds to spot him in the crowd. He was standing next to his mother, who seemed to be looking right past him. Tony thought they looked the same, yet different—were they skinnier? Wearing new clothes? His father had combed his hair straight back, and his mother was wearing makeup. He walked up to them, and only then did his mother's eyes seem to focus and find him. She took two big steps forward and hugged him, was already crying.

"You're so skinny," she said. "I told him to watch your diet, not starve

you! We need to get some lunch. Are you hungry?" She held his face in her hands and looked at him, smiling, still crying. "Oh, you look so...so different."

"You, too," he said. "Stop crying, Mom."

She would not let go until his father pried her off of him. He stood back and looked at Tony, smiling and nodding. "You look good," his father said. He hugged Tony hard and gave him a firm slap on the back. He said, "Let's get your stuff and go home," but Tony knew he already was.

CHAPTER 17

*M*ay 1996

There was a knock on his door, laughter and footsteps outside.

"T, you in there? We're going for lunch."

"Nah, I'm good. I have to study. Leave me alone."

"Cool," the voice said, and the footsteps moved away.

He could study in his room because his roommate, a chemistry major, was always in the library or lab, and so the room was more or less his all the time. Not that he minded the library (or his roommate for that matter), but most of his work was reading or drawing, so if he could work from the comfort of his own bed, then why not?

He looked at the calendar on the wall: just a few weeks before finals, then he would be heading back to the Bronx. His parents were renting a truck to come get him and his things, the same way they had packed him up and dropped him off last August. It wasn't a bad ride, just a couple hours out of the city, which was part of the reason why he had chosen New Paltz: they had given him a scholarship, had an art program that he liked, and it was close to home, so his parents could not object too much. His father had wanted him to go to school in the city and live at home, but

it was his mother who had said, "No, he needs to go away, live on his own. If anything happens, we can be there in a couple hours."

"Does the subway run upstate?" his father said. "I don't think so."

He had not been meant to hear this, had thought his mother would want to keep him home and baby him, that his father would be the one ready to send him out into the world. He didn't want them to fight, to be worried or disappointed, at least not over this. But as soon as he had set foot on the campus, met all the other freshmen in his dorm (a mix of black and white and Hispanic kids, mostly from the city or Long Island, some from upstate), all of them friendly and excited, silently eager to be rid of their parents so they could get on with their new lives, he knew he had made the right decision.

There were adjustments, of course, to living upstate (as he called it, but his friends from Syracuse and Rochester told him that this was mid-state at best), crammed in a boxy dorm room and living with strangers, surrounded by trees and fields and so much greenery. At night, as he fell asleep, he no longer heard the sounds of traffic and trains, or planes flying overhead to and from the airport. Instead, he heard the wind and trees rustling, a single car horn or engine rumbling by. It took nearly a month before the quiet began to feel normal.

The winter was rough, felt like it was twenty degrees colder up there than it did in the Bronx, and he did not like the snow, which was twice as heavy as anything he had ever seen while living in the city. But being locked down by the cold and snow forced him to do his work, and there was plenty of it. First semester he took composition, a course on modern China, and a class on the history of race and racism, along with his drawing and integrated design classes; second semester was Comp Two and The Novel, and then more drawing and design classes. By March, he had decided that he was going to get his BFA in art with a concentration in painting and drawing, which meant always having a full plate of work and little time to mess around.

In his last two years of high school he finally had his growth spurt. Now he was five-foot-seven, as tall as his father and average height, which was all he ever wanted to be. He had not gained back any of the weight he had lost, but still had to work to keep it off, knowing he had a natural propensity to gain weight if he did not exercise and watch what he ate. These days he made time to run, enjoyed jogging around the pond and along the stream that ran through campus, doing push-ups and sit-ups and pull-ups in his room or beneath a tree in the quad, or lifting weights in the campus gym.

He had a girlfriend now—she was from Plattsburgh, New York, which was closer to Canada than it was to New York City, and to her, living in New Paltz might as well have been Miami. "You *really* don't know cold," she told him. He had shown her his paintings, and she had loved them on sight. "You're talented," she said, and he said, "I don't know. I'm trying." She was an English major who wrote poetry and even though he did not understand all her poems, he thought her and all her words beautiful.

Though he missed his parents on occasion (he had not told them about his girlfriend), he did not necessarily miss home—the restaurant or the work or the noise of the subway waking him from sleep every night. After returning from his summer in Shanghai, John told him that Victor Ramirez had been expelled for breaking into the school and stealing a television and VCR. "Got caught trying to sell the stuff on the *stoop* of his *building*," John said, and they both shook their heads at this brazen act of stupidity. So he did not face imminent destruction as soon as he stepped back into the school's halls, those dark corridors that did not seem so dark or threatening any-more. Otherwise, things were the same: the classes, the teachers, the school-work. The Mole's car was repainted, repaid; so was the school wall. Maria did not come to love him, nor did he continue to pine for her. John remained his only good friend, and they both graduated near the top of the class.

He was glad those days were over, did not recall fond memories of his old life. When he did reminisce, he thought of Min, where she was and

how she was doing; and he thought of his uncle, who had bought a small restaurant, not quite as busy or upscale, but one that was truly his. He thought of Master Zhu often when he was working in one of the school's fine arts studios, remembered his words: "…a place where you can clear your mind and concentrate…block the outside world." They had not traded letters in over a year, and he wondered what Master Zhu would have thought of these vast and elaborate facilities, knew that Master Zhu would be happy for him and proud that he was forging a path to a life he and he alone had chosen.

When he got the letter, he thought his mother was crazy; he was going home in a week, so why send letters now? Just pick up the phone, he thought. He tore the envelope open, shaking his head.

Then he saw the cluster of pages and the note stuck to it that his mother had scrawled.

"From Mrs. Zhu in Shanghai. I try to write what she
write. Sorry not perfect. Want to tell you ASAP. We so sorry.
Love,
Mom."

He read the letter once, then again, his mother's translation rough and choppy. But it was clear enough what had happened—Master Zhu had spent the past year recovering from a stroke and fighting through several bouts of pneumonia. But in the end his lungs were not strong enough, and he had passed away in late April, peacefully surrounded by family. He was one hundred and five years old.

His mother's letter said that Mrs. Zhu wanted Tony to know that Master Zhu was always happy to receive his letters and get news about his young American friend; that he beamed when he heard that Tony was going to college to study art; that he often talked about how smart and how good a boy he was, how he had fire and enough talent that he might be able

to live a life doing something that he loved. She was sorry to have to tell him like this, wished that there was an easier and more personal way of doing it. But Tony did not blame Mrs. Zhu, knew that there was no easy way to explain such things.

He sat on his bed with the letter in his hands, staring at the Chinese characters, wishing he could read them for himself. He folded the letter and tucked it in the desk drawer. He could hear people outside walking to and fro, voices carrying with the light spring breeze. There were so many trees and such a big sky around them—he thought Master Zhu would have appreciated the calm and tranquillity of the campus, the sun high and warm, a cooling breeze blowing off the pond, mountains ringing the distance. He decided that when the time was right, he would paint it all and send it back to Mrs. Zhu with a letter telling her how he felt. He didn't know exactly what to feel right then: he was sad that Master Zhu had been so sick, sad that such a great man was gone. And who would replace such wisdom and kindness once it had passed from the earth?

Then he looked at the wall over his desk, the framed painting that Master Zhu had given him of the gold-and-crimson, emerald-and-violet shining towers of Shanghai, the two tiny figures of them walking through the valley of afterglow; and Tony told himself to be happy that he had known Master Zhu, that he was lucky to have had the chance to learn from him and now keep him as a part of his life. When he had first been given the painting, it had meant one thing to him—to remember; and now he felt the infusion of a new and vivid spirit, noble and everlasting, timelessly reborn.

ZHU QIZHAN'S LIFE AND ART

Like other artists from his time period, Zhu Qizhan did not achieve fame until later in his life; and though Zhu came to accept and enjoy the byproducts of his renown, they were always secondary to that which was most important to him: his work.

Born to a wealthy family in 1892 in Taicang, Jiangsu Province, Zhu Qizhan began studying Chinese painting with a private tutor at the age of seven. In his twenties he became a professor at the Shanghai Arts Academy, and then later traveled to Japan where he studied Western-style oil painting, and was heavily influenced by European painters such as Van Gogh, Matisse, Picasso, and Cezanne. This influence can be seen even in Zhu's later works.

Zhu's blending of Western and Eastern influences, techniques, color usage, and style demonstrates his mastery of both ink and oil painting, and is symbolic of his lifelong quest to be consistently growing and developing as an artist. Just as amazing is the perpetually changing time during which Zhu continued to find a way do his work and improve upon his craft.

For Zhu's life spanned one of the most tumultuous centuries in China's vast history. He lived through the Boxer Rebellion in 1898, the fall of the Qing Dynasty in 1911, China's civil war between the Nationalists and the Communists during the 1920s and '30s, the Sino-Japanese war and World War II, the founding of the People's Republic of China in 1949, Mao Zedong's persecution of artists and intellectuals and all things "old" during the Cultural Revolution (1966–1976), and well into China's contemporary age of economic and social development in the 1980s and '90s.

Zhu's mark on Chinese painting is significant as he bridges the discipline and philosophy of traditional Chinese painting into a new age. Admired and respected by connoisseurs and artists alike, by the late 1980s Zhu had already outlived many of his contemporaries. But by that point Zhu's free-flowing style, best known for his bold and decisive brushwork as well as his vibrant and daring use of color, had found a new audience with a younger generation, and so his popularity and influence only continued to grow.

In his later years, Zhu's work became widely sought after and was exhibited to great fanfare in Europe and the United States as his fame spanned the globe; fittingly so, as Zhu was one who loved to travel. He visited New York City in 1986, where his work was exhibited and where he saw for the first time the Metropolitan Museum of Art and the Modern Museum of Art. He was amazed, astounded, overjoyed by the experience.

Zhu Qizhan died on April 22, 1996, at the age of 105. He is remembered as a man who lived like the willow tree, bending but never breaking, simply swaying beautifully and naturally, always adapting to the wind.

A Time Line of Zhu Qizhan's Life

1892 Born in Taicang, Jiangsu Province.

1899 The Boxer Rebellion.

1900 Begins to study Chinese painting with a private tutor; Tong Songyu.

1908 Enters the Shanghai Business School.

1910 Returns home because of ill health.

1911 Fall of the Qing Dynasty; establishment of the Republic of China.

1913 Appointed Professor at the Shanghai Fine Arts Academy.

1917 Travels to Japan to study oil painting and drawing with the celebrated painter Takeji Fujishima.

1928 Establishes the Garden Fine Arts Academy.

1929 Participates in the First National Fine Arts Exhibition. *Early Spring* included in the exhibition catalogue. Organizes the First Exhibition of the Garden Fine Arts Academy.

1930 *The Painting of Zhu Qizhan* published in Shanghai.

1931 Appointed Professor of the Shanghai Xinhua Art College.

1932 One-man show of oil paintings reflecting the Chinese struggle against the Japanese in Shanghai.

1934 Appointed Director of the Shanghai Xinhua Art College.

1937 Travels to Japan to do fine arts research. Participates in the Second National Fine Arts Exhibition.

1942 Mao Zedong's Yanan Forum on Art and Literature.

1946 Establishes the Plum Blossom Cottage in Shanghai.

1949 End of the Civil War in China; establishment of the People's Republic of China.

1955 Joins National Association of Artists. Appointed staff member of Shanghai Center of Culture and History.

1956 Joins the Shanghai Chinese Traditional Painting Institute.

1957–1958 Hundred Flowers Campaign against traditional (rightist) intellectual thought.

1966 Cultural Revolution begins.

1966–1970 Forced to sit on the floor at the Shanghai Fine Arts Academy every day to be criticized and beaten, made to study Mao's writing and to write papers of self-criticism. Sweeps the streets of Shanghai.

1971–1975 Because of ill health, is allowed to remain at home to paint copies of ancient paintings.

1976 Cultural Revolution ends.

1976–1979 Travels to Jiangsu, Beijing, Guilin, and Hubei with his family. Paints murals for the Jingan Guest House and the Peace Hotel in Shanghai.

1980 *The Collected Works of Zhu Qizhan* published in Shanghai.

1981 One-man show travels to the Shanghai Art Exhibition Hall, the Jiangsu Art Exhibition Hall, the Sichuan Chengdu Art Exhibition Hall, and the Beijing Fine Arts Exhibition Hall. Appointed Professor at East China Normal University. Honorary position as advisor for the Art Studio at Zhaotung University. Published *Bi Xi Ju Studio*. Travels to Beijing.

1982 One-man show at the Guangdong Provincial Museum. Film, *The Artist Zhu Qizhan*, is made. Thirty-three works donated to the Shanghai Art Exhibition Hall. Six works donated to the China Art Exhibition Painting exhibited in the Salon du Printemps in Paris, France. Travels to Guangdong and Fujian with Shanghai artists. "Master Painter Zhu Qizhan" published in *Chinese Literature*, March 1982.

1983 *Selected Works of Zhu Qizhan* published. Travels to San Francisco. Paints a large mural in the San Francisco airport. Meets Ansel Adams in San Francisco. Travels to Japan. Travels to Yunan with Shanghai artists. Exhibits paintings in an American traveling show of contemporary Chinese artists organized by the Chinese Culture Center of San Francisco.

1984 Exhibited in "20th Century Chinese Painting" at the Hong Kong Museum of Art Exhibition and catalogue: Institut fur Auslandsbeziehungen, West Germany.

1985 One-man show in Hong Kong.

1986 Travels to New York. One-man show at LJ Wender in New York City (his first one-man show in America). "Fusing East and West" published in *Newsweek*, March 24, 1986. Appears on ABC Eyewitness News. Travels to Houston, Texas. Travels to Hong Kong. Exhibition of paintings by Zhu Qizhan in Shanghai Art Exhibition Hall and Beijing Fine Arts Exhibition Hall for his 95th birthday. Travels to Beijing and Guangdong.

1987 "Personal Recollections of Chu Ch'i-Chan" published in *Arts of Asia*, July–August 1987.

1988 *The Art of Zhu Qizhan*, one-man show, National Museum of Art Gallery, Singapore.

1990 100th Birthday Celebration Exhibition in Shanghai in March, in Hong Kong in April. Exhibition publication. Fifth annual one-man show at LJ Wender in New York City and 100th birthday celebration in May and June. One-man show of landscape paintings at Research Institute of Chinese Art in New York City.

1994 *Encounter with Zhu Qizhan*, Hong Kong Museum of Art Exhibition publication, 2 volumes.

1995 *Contemporary Chinese Painting: The Art of Zhu Qizhan*, The British Museum, February–May. 105th Birthday Celebration Exhibition. Official Opening of the Zhu Qizhan Museum of Art, Shanghai, May 5th. One-man exhibition at the Asian Art Museum of San Francisco, July–October.

1996 Zhu Qizhan passes away on April 22nd at the age of 105.

1996–1997 *Zhu Qizhan: His Zeal for Art, His Zest for Life*, in Singapore. *Zhu Qizhan: Works From the Master*, The Art Center at Hargate, Concord, New Hampshire, September–October and Thorne-Sagendorph Art Gallery, Keene State College, New Hampshire, November–December. *Legacy from the Plum Cottage: Zhu Qizhan Paintings*, Shanghai.

1999 Retrospective Exhibition at China 2000 Fine Art, New York.

2001 *Treasured Collection of Zhu Qizhan's Paintings Exhibition* (celebrating the 110th anniversary of Zhu Qizhan's birth), Zhu Qizhan Museum of Art, Shanghai, April 22–May 5. Publication of *Treasured Collection of Zhu Qizhan's Paintings* and *Selected Critical Essays on Zhu Qizhan's Art*.

2002 Exhibition of paintings at China 2000 Fine Art, New York City. "Zhu Qizhan: A Noble Spirit" published in *Arts of Asia*, May–June 2002.

Acknowledgments

I would like to thank Leon and Karen Wender of China 2000 Fine Art in New York for sharing with me their memories of Master Zhu, for providing me with their exhibition catalogues of Master Zhu's work, and for the amazing wealth of detailed information and analysis included in those catalogues. Without their assistance I would not have been able to write this book, and for their support I am deeply grateful. For more information on China 2000 Fine Art, visit them online at www.china2000fineart.com.

Thank you to Jacqueline Ching and Brian Phair at Watson-Guptill: Jackie, for approaching me with this opportunity; and Brian, for his keen editorial insights that have helped to improve the book on so many levels.

Finally, I want to thank my wife, Jennifer, for supporting me and always believing in me. You are my life, my love, my partner, my bun.

About the Author

Terrence Cheng is the author of *Sons of Heaven*, a novel set during the Tiananmen Square Massacre in 1989. *Publishers Weekly* noted that *Sons of Heaven* was "a rare find...not the first novel to center around Tiananmen, but it may be the best." Cheng earned his MFA in Fiction at the University of Miami, Florida, where he was a James Michener Fellow, and in 2005 he received a Literature Fellowship from the National Endowment for the Arts. Cheng teaches creative writing at Lehman College, part of the City University of New York. For more information visit www.tcheng.net.